Art an Enemy of the People

PHILOSOPHY NOW

General Editor: Roy Edgley

English-speaking philosophy since the Second World War has been dominated by the method of linguistic analysis, the latest phase of the analytical movement started in the early years of the century. That method is defined by certain doctrines about the nature and scope both of philosophy and of the other subjects from which it distinguishes itself; and these doctrines reflect the fact that in this period philosophy and other intellectual activities have been increasingly monopolised by the universities, social institutions with a special role. Though expansive in the number of practitioners, these activities have cultivated an expertise that in characteristic ways have narrowed their field of vision. As our twentieth-century world has staggered from crisis to crisis, English-speaking philosophy in particular has submissively dwindled into a humble academic specialism, on its own understanding isolated from the practical problems facing society, and from contemporary Continental thought.

The books in this series are united by nothing except discontent with this stage of affairs. Convinced that the analytical movement has spent its momentum, its latest phase no doubt its last, the series seeks in one way or another to push philosophy out of its ivory tower.

Other books in the Series:
PHILOSOPHY AND ITS PAST: *Jonathan Rée, Michael Ayers, Adam Westoby*
RULING ILLUSIONS: *Anthony Skillen*
SARTRE: *Istvan Meszaros*
SOCIAL SCIENCE AND SOCIAL IDEOLOGIES: *Roy Bhaskhar*
FREEDOM AND LIBERATION: *Benjamin Gibbs*
HEGEL'S PHENOMENOLOGY: *Richard Norman*

Art an Enemy of the People

ROGER TAYLOR
University of Sussex

THE HARVESTER PRESS

First published in 1978 by
THE HARVESTER PRESS LIMITED
2 Stanford Terrace, Hassocks, Sussex
Publisher: John Spiers

British Library Cataloguing in Publication Data

Taylor, Roger
Art, an enemy of the people. — (Philosophy now;
vol. 3).
1. Aesthetics
I. Title II. Series
700'.1 BH39

ISBN 0-85527-941-9
ISBN 0-85527-991-5 Pbk

Typeset by Red Lion Setters, Holborn, London
and printed in England by
Redwood Burn Ltd., Trowbridge and Esher

CONTENTS

1. Methods of Thinking and Methods of Work 1
2. Correcting Mistaken Ideas about Art and Culture 29
3. The Fraudulent Status of Art in Marxism 59
4. A Warning of the Corrupting Influence of Art on Popular Culture 89

For Len Taylor, my father

Chapter One

METHODS OF THINKING
AND METHODS OF WORK

This book is about art and philosophy. To say this is, thereby, to put it beyond the reach of the masses. By 'the masses' I mean the mass of people in my own society, as I know it. As an academic I have little more than vague relationships with members of the masses. Those with whom I have such vague relationships include, to make the point vivid, the postman, the milkman, the refuse collectors, those who come to service items like washing machines, people who work in shops, people who sell vehicles and neighbours who work, for instance, in the building trade and the police force. For such people that this book is about art and philosophy, more as a matter of fact than surmise, puts the book beyond their reach. This is disconcerting. Can anything be done about it?

To begin with, the problem is not confined to what one might wish to attempt in one's book. The problem extends to the publishers and their concept of a book. It is unthinkable that a publisher would conceive of a book on art and philosophy as being marketable to the general readership of the *Sun* newspaper. Even a 'coffee table' history of art and philosophy would not be aimed at the general *Sun* reader. It is possible one might induce readership if the pages of the book were liberally interspersed with photographs of good-looking men and women, in various states of undress, illustrating (humourously) points in the text. Personally, I

would find this desirable, and would buy many more theoretical books than I do if they were standardly presented in this way. However, in general, there is a reluctance in the publishing world to mix modes like this. Books on art and philosophy etc. constitute the holy side of the publishing business, offering publishers a sense of recompense for what they are likely to regard as the dirtier side of the business. The fact that I can countenance a mixing of modes in this way says, indirectly, quite a lot about how art and philosophy will be approached in this book.

The idea of bridging some cultural gap normally springs from missionary motives. It is for this reason that murmurs of disapproval would greet this book if it was to include titillating pictures. My intentions, however, are anti-missionary. To state my position in its most challenging form I hold that art and philosophy are enemies of the masses. Therefore, it is not my intention to bring art and philosophy to the masses, but, rather, arm the masses against them. It is for this reason that I would have the masses read this book. As things stand the masses, somewhat shamefacedly, ignore art and philosophy; I wish to stir up an arrogant awareness of and resistance to these activities. The 'cultural' life of our society is a confidence trick practised on the masses. The masses pay in two ways. Firstly, through their pockets in financing the educational system etc., which is itself ideologically committed to the 'cultural' life, and, secondly, through a general sense of inadequacy (concealed) when measuring themselves against the range of skills the social order demands. The masses should interest themselves in 'cultural' activities in order to see how these are confidence tricks practised against themselves, and therefore, how to resist them. This book is, then, about art and philosophy in an unusual way.

Another barrier to reaching those I would reach lies in my own position. Over a decade spent, exclusively, in the academic world is very poor training for communicating with the masses, although it is very good training for a courteous

distancing of oneself from others (thereby one communicates a respect for social hierarchy). A certain sentence structure, vocabulary, the disposition to labour so as to make all arguments logically watertight, these are academically acquired traits which do not recommend one to the broad mass of people. However, to pretend to a voice, which is the voice of the masses, or to resolve to explain oneself by constantly making allowances for the ignorance of others is, in the first case, hypocrisy and, in the second, incapacitating (and, in any case, one would probably do it all wrong). Therefore, despite barriers, I intend to write this book as naturally as I can, that is, without conscious affectation. The material to be dealt with is not easy but neither is it impossibly difficult. Where difficulties are experienced because of the style, or the words used, then I ask that the reader should *make allowances for my background*. In fact, the language I use is not really technical, and most difficulties, if there are any, can be cleared with the aid of a dictionary. Where the sense of, what might seem to be, tortuous sentences eludes the reader the best remedy will be to read on. In due course the main point will emerge. These comments are offered in the hope that this book will prove an exception to rules about who reads what. This hope is not optimistically entertained, but the book is written on this basis.

To begin on the main substance of this book I shall concern myself with some remarks on the world of philosophy as I have experienced it. My early training in philosophy gave me two perceptions of the world which most people would not naturally come by, in fact the world as it affects most people prevents them from these perceptions, or outlooks. The first perception was that there were *concepts*. In fact, the prevailing view of philosophy that was taught to me (there are and have been many views as to what philosophy is) was that philosophy was concerned with the analysis of concepts. What did I understand by concepts? My perception of this was not philosophically clear, but it was, I

think, clear enough for ordinary understanding. I could give instances of concepts. For instance, I would cite the concept of truth, of meaning, of justice, of causality. All of these are concepts of some importance in the history of philosophy. However, concepts are not confined to those which have preoccupied philosophers. One could, for instance, sensibly talk about the concept of a tree, of fire, of sexual experience, of a book. Concepts come into the world through our consciousness of the world. To think of concepts, in this way, was to give rise to the perception that the concepts we have of the world might not accurately reflect the world. Most people would find it easy to suppose that how they believed the world to be might be other than it was, but the idea that the materials with which we thought, the concepts of flowers, trees, fires, sexual experiences, truth, justice etc., might, in themselves, represent an inaccurate classification of the world is more difficult to grasp. The real perception of the possibility can, perhaps, only come, for good or ill, after considerable immersion in philosophical activity. Anyway, this was the first perception.

The second perception, which can be linked to the first, though it came with relative autonomy, was that values were distinguishable from facts. Most people operate under the assumption that the goodness and the badness of people and their deeds is as certain as there being people and a world that they inhabit. On the other hand the philosophical arguments the young student of philosophy was, and still is, asked to study produced an unease about values. The question was raised as to how to establish values, and once you raise the question you realise how difficult it is to answer. Most people do not pose this question for themselves. For them the values of the society are just accepted even if they don't live up to them.

These two perceptions were related to each other. When talking of values we are talking of concepts. We have concepts of goodness, badness, rightness, wrongness, etc. Perhaps there is nothing in the world which answers to them.

Perhaps they are *just* concepts; things we have made up.

I do not, at this juncture, wish to persuade anyone of this, my purpose is different. It is, in part, to communicate to those, who have no conception of such thoughts, something of what it is like to be a person in the world thinking like this. Most people can easily imagine everything that lies around them being an illusion or part of a dream. TV is full of dramas in which all sorts of things seem to happen to someone who subsequently turns out to have been dreaming all along. To feel the possibility of a gap between concepts and the world is, however, to feel sceptical about the very language one speaks. Perhaps language itself is an illusion. Perhaps one should be unsure of each and every word one uses. Most people just talk; the words pour out; they have and need little consciousness of their language activity. Sometimes there is an awareness of the problem of handling one's language in socially acceptable ways, but few people get to the point of doubting that language is adequate. I suspect the word 'language' helps to clarify what I am saying about concepts and values. What has to be imagined is language being a prison from which we cannot escape; a prison of illusions. This is a rough description of what early exposure to philosophy induced in me. Values became something one was not sure of; an area of uncertainty. Every assertion in the language had to be greeted with the question 'What does it mean?'. Even the simplest acts of language could not be taken on trust, but had to be quizzed to see if any significance could be wrung out of them.

It is quite wrong, I am convinced, to be so sceptical of the language we speak. This is so, if only because any scepticism about the language is voiced within the language. If the language does not make sense, then neither does the attempt to coherently state that this is so. However, as I have said, it is not the rightness or wrongness of this position that I am concerned with. My main interest is to prepare the way for making intelligible the significance of my examination of 'cultural' activities.

To pursue this I need to talk next about methods for understanding concepts. There was a certain view about how this was to be done, which the philosophy I was introduced to as a student questioned. The view questioned put forward what I shall call an abstract method. This abstract method constitutes what much of philosophy has been about. The method was that of analysis and definition. First of all there was the assumption that the totality of reality (all there is) could be exhaustively analysed into its component parts. When this was done the second aspect of the method took over, namely, the task of producing definitions to cover the individual concepts analysed. Let me give a trivial but intelligible example. It might be asked, 'What is a motor-cycle helmet?' To answer this we might say it is both a functional object and a material object. That it is a form of headgear designed to protect the motor-cycle rider in case of accident, and, also, a certain quantity of material substance, e.g. glass fibre. At the functional level we might go on to sub-divide the object into the outer protective shell, the inner padding, the visor, the press studs etc. All of these functional items could be related to distinguishable quantities of material substance. The glass fibre for the outer-dome, the fibrous and rubber substances in the padding, the polythene, perspex substance in the visor, the metallic content to the press studs. This analysis could go on endlessly, although it was an assumption of the method being discussed, that it would be possible to exhaustively analyse all the characteristics and properties of what one analysed. From this list of properties of motor-cycle helmets we might try to pick out those which are essential to something being a motor-cycle helmet. If this could be decided, these factors, when listed, would constitute the definition of motor-cycle helmet. The definition would specify those conditions necessary and sufficient for something being a motor-cycle helmet. This activity of defining could next be applied to all the components of motor-cycle helmets. If this task could be carried out, it might be thought, one would then know all there was to know about motor-cycle helmets.

A great many philosophical works are composed in this way, only their subject matter is *the universe*. A selection of philosophical works throughout the ages would demonstrate the similarity of style. The works of Aristotle, Spinoza, Hume, Russell constitute a representative sample.

The philosophical tradition I was exposed to, which challenged this methodology, was one stemming from the work of the twentieth century philosopher Wittgenstein. The attack went as follows: If you examine a concept like motor-cycle helmet there is a temptation to suppose that everything called a motor-cycle helmet has something in common with everything else so called. The temptation is that of supposing there to be some essence, some common core. However, this temptation is misguided because it fails to recognise that concepts come into the world at particular times (this is to say they are not there from the beginning of time) and that subsequently, they develop and change. If you suppose for every concept there is, there is some common core, then you are being over logical about concepts, and are, consequently, not allowing for the fact that concepts are developed by human beings over considerable periods of time.

A good analogy here is the development of roads. An over logical view of a country's road network might insist that the point of a road between A and B was to provide the quickest, shortest and most efficient means of moving from the one place to the other. However, those who travel the road may feel they had good grounds to doubt this and would propose much better routes. It might only be after studying the social history and geography of the area, in which A and B were situated, that one might come to a real understanding of the route taken by the road. Thus, one might discover that once there had been an important town C between A and B and that originally there had been two fairly distinct roads linking A to C and B to C. Subsequently, the importance of C may have waned and the importance of A and B increased, so that the old routes A-C and B-C were combined to make the major route A-B. A concentration on the history and

development of the road explains it, whereas the over-logical, definitional view is, in comparison, too abstract for understanding the real process of the world. The same is true of concepts. To insist on finding a neat definition to cover any concept examined is to turn away from the reality of the concept as a developing organism. The concept of motor-cycle helmet is one changing through time. The concept itself emerges from earlier concepts of helmets and throughout its history it is applied to a very varied range of objects. It may prove impossible to find some characteristic which all motor-cycle helmets share, which also serves to mark them off from all other objects. It might be suggested that all motor-cycle helmets are designed to be worn on the head whilst the wearer rides a motor-cycle, but then there are other objects so designed which are not motor-cycle helmets, for example, woolly hats designed in the colours of motor-cycle manufacturers, for trials riders. It might be suggested that for something to be a motor-cycle helmet it needs to be made of some rigid material, but there are old fashioned motor-cycle helmets made out of pliable leather which do not satisfy this condition. Moreover, even if it was possible to find some conditions which as of now uniquely characterised motor-cycle helmets, we might find, subsequently, that the concept developed so as to meet new social needs, and that, therefore, the definition became inapplicable.

One of the concepts Wittgenstein directed the attention towards in this way was the concept of game. This is a well known example in the history of recent philosophy, but none-the-less I quote the passage.

> Consider for example the proceedings we call 'games'. I mean board-games, card-games, ball games, Olympic games and so on. What is common to them all?—Don't say: 'There *must* be something common, or they would not be called "games"'—but *look and see* whether there is anything common to all.—For if you look at them you will not see something that is common to *all*, but similarities, relationships, and a whole series of them at that. To repeat: don't think, but look!—Look for example at board-games, with their

multifarious relationships. Now pass to card-games; here you find many correspondences with the first group, but many common factors drop out, and others appear. When we pass next to ball-games, much that is common is retained, but much is lost.—Are they all amusing? Compare chess with noughts and crosses. Or is there always winning and losing, or competition between players? Think of patience. In ball games there is winning and losing; but when a child throws his ball at the wall and catches it again, this feature has disappeared. Look at the parts played by skill and luck; and at the difference between skill in chess and skill in tennis. Think now of games like ring-a-ring-a-roses; here is the element of amusement but how many other characteristic features have disappeared! And we can go through the many, many other groups of games in the same way; can see how similarities crop up and disappear.

And the result of this examination is: we see a complicated network of similarities overlapping and criss-crossing, sometimes similarities of detail. (L. Wittgenstein, *Philosophical Investigations*, Oxford, 1953)

In summary form, the method I was exposed to attacked the older, more abstract methodology by directing attention away from concepts as coherent entities and towards concepts as diverse uses of language. Questions about the concept of meaning or truth or games etc., became questions about how the words 'meaning', 'truth' and 'game' were used in the English language. The assumption was that these words would display a variety of uses, so that the business of analysing a concept became that of displaying the various uses of a word and its derivatives. This movement in philosophy was known as 'linguistic philosophy'. It was a movement which tended to debunk the problems in the history of philosophy. The history of philosophy was thought to be full of knotty problems which only came about because people had insisted that questions about the nature of concepts receive neat, logically water-tight answers. The history of philosophy was the history of people inventing such answers (often with great ingenuity) and others refuting them (with equal ingenuity).

This, then, was something of the philosophical climate (conceived of, that is, in theoretical terms) when I entered into the life of philosophy.

So far the introduction to the main themes of this book has been semi-autobiographical. This has enabled me to introduce certain ideas upon which I wish to build.

When we talk of concepts we should not divorce them from the language we speak. Thus, to understand our concepts is the same as understanding the language. In other words, when people posit abstract questions about the nature of truth or justice or freedom one should not be taken in by the assumed correctness of proceeding abstractly. Certainly, one should not be taken in by the complex, baffling to the uninitiated, definitional answers which are given to these questions. Whole forms of life, distinct social groups, are borne on the strength of these theoretical activities, and their real significance is not confined to the significance of the theoretical pronouncements. The various social groups involved have been linked, as is every social group in a society, to the society's power structures. The link has often been one of them forging the ideology of the society (i.e. the set of ideas in terms of which the society is said to be organised) which the mass of the people would do well to avoid being organised by.

The point I am making here is not being made abstractly but it is very general and, perhaps, an example is clarifying. In our society the concept of a free society (which is held to be ideal) is defined as a democratic society, and this latter concept is defined as a society in which all the people can elect whom they like to govern their society. This is the main line of thought, although there are many qualifications and modifications built into the ideology so as to meet the challenge of intellectually inspired scepticism. It is held that British society satisfies the definition of a free society and that the people of a free society are themselves free. Therefore, it is held the people are neither slaves nor are they dictated to. The Soviet Union calls itself a democratic society but, from the viewpoint of Western ideology, this is held to be absurd as the people of the Soviet Union cannot elect whom they like to govern the society. On the basis of these

largely theoretical pronouncements many people in the society, in so far as they bother to consider the matter, regard themselves as free persons in a free society. However, these abstract considerations blunt one's real perceptions of the society and real understanding of the ways the word 'freedom' (the concept of freedom) applies to one's life. Thus, the fact that the people can elect any government they want (which in itself is an inaccurate way of talking about the real situation in British society) is irrelevant if the government is not in control of the social processes within the society. Things like this can only be determined by looking closely at what goes on in the society. Moreover, the freedom of the people is an empty abstraction compared with the real significance of applying the word 'free' to the lives of individuals. Is the individual free to determine how much money he earns? Is he free to determine what work he does? Is he free to decide on the level of production in his place of employment? Is he free to choose where he lives? Or are the people as a collective entity able to decide these things, and others, for themselves?

Abstraction in the first place needs to be challenged by the actual usage of the language. It was in this way that the 'linguistic philosophy' movement stripped the history of philosophy of its heavy, sonorous problems. The importance of this requires emphasis. For a great number of people there is a gap between what they would call the theoretical and the practical. Most people feel they have some grasp of the practical but believe themselves unsuited to the theoretical. This divide has social consequences in so far as success at theoretical activity is one of the measures whereby the rewards of the society are apportioned. Despite this, there is a vast, popular mistrust of theoretical activity and theoreticians. This mistrust is, it seems to me, healthy where it directs attention back to the real processes of the world and away from the illusory efficiency of abstraction.

This is not to say that theories about the real processes of the world are thereby suspect. What is the case is not always

self-evident and theories as to how it is are the means to discovering how it is. Theory is suspect when it proceeds as a world unto itself, yet supposes it is in a position to accurately interpret and relate to the world. Typically, this happens when a conceptual system or language, which derives from human beings dealing with the world, is abstracted from its sphere of employment and thence hounded with great logical precision for logical consequences. The inaccuracy that creeps in stems from a turning away from the real processes of the world. Some movements in philosophy have pointed to the reality of the danger. Trivial examples of the problem abound like the fact that it would be wrong to suppose that because any number can be divided again and again (i.e. infinitely) that, therefore, an object, whose length can be expressed as a numerical dimension, can also be infinitely divided.

The history of philosophy is full of more significant errors, which have derived from abstract methodology, like the contention that nothing moves but only seems to, or that goodness is an object existing in some non-earthly place, or that god is everything there is and everything there is is god, or that we necessarily live in the best of all possible worlds. However, the dangers are not confined to philosophy. Examples of people, societies, whole cultures falling into them abound. There are obvious, practical repercussions of organising the world in accordance with abstract perceptions. Thus, when an airport is situated on available waste-ground, but where the planners fail to relate its situation to the surrounding environment, then the airport, and its consequent social problems, result from its planning abstracting it from real and surrounding social process. Or, when a planner finds it possible to draw a line on a map and thus builds on the ground in accordance with the line on the map, but fails to observe and relate to the full social and physical complexion of the area. Here, the concrete misery of possession orders or of, as in a recent case, the undermining of the clay strata and the consequent fall in the water table producing

subsidence, result from the abstractness of the plan. In such a case, the conceptualisation of the place, i.e. the map, becomes the basis for judgement, rather than an aid to the location of the place as a developing, changing entity. Or, to take another case having obvious practical implications, when a motor-cycle licence qualifies you to drive a three-wheeler car because the original three-wheelers were basically motor-cycles having three wheels. The concept of the three-wheeler or tricycle (as it is referred to legally) being set up in this way has prevented legal recognition of the fact that the three-wheeler is now basically a car lacking the fourth wheel. Here, we can see the society's conceptual system having a life of its own, abstracted from the real processes of the society.

In the employment of abstract methodologies it may be that there are larger, concealed, practical implications involved. On an abstract consideration of concepts, or the language, the relationship between them and the world is one of their being classifications of the world into which the world is supposed to fit neatly. This is opposed to another view of language, which seems to me more realistic, whereby language is seen as the various methods we have for indicating, pointing to, signalling towards the processes of the world (processes which can never be categorised by means of static definitions, simply because they are processes). The abstract characterisation of language is not going to be an arbitrary, motiveless choice by a cultural group. It is going to be related to the activities of the group. We might speculate that a function of the characterisation, and the attendant organising principles of a society is one of appearing to have fixed for once and for all what is not permanently fixable, namely a volatile, ongoing reality. Perhaps, then, it is not surprising that the dominance of logic, and its attendant intellectual disciplines and dispositions, has been within a cultural tradition which has had the most significant, approximate success at fixing the world in accordance with human intentions. If an abstract methodology comprehends the world as fixed and static then, perhaps, its adoption is part of the practical

project of trying to fix things so they will not need fixing again. It is also the case that in less technological and scientific cultural traditions (as in the East, for example) a greater allowance is made for the eroding and elusive flow of processes. However, this is a speculation and should only be heeded if actual, historical, human processes can be followed through in detail so as to confirm it. To insist on such a method of proceeding is the negation of an abstract methodology.

Language is, then, one of the ways we have of dealing socially and individually with a changing, unfixed world. However, language itself is not outside the processes of the world, but is a process in the world. It is the implications of this thought which 'linguistic philosophy' never digested. The point is that if the conceptual system is in process, then to understand it we must be concerned with its development. In other words to understand the language we must be concerned with its history. 'Linguistic philosophy', in its rejection of an abstract methodology, was content to bring to the fore what it was natural and what it was odd for people in the cultural group, who concerned themselves with 'linguistic philosophy', to say. In this way an attempt was made to chart the various uses of language, as it existed, at one particular time, for a particular social group. The possible limitations imposed by such restricted samples passed by unnoticed. It was assumed that to understand the conceptual system, from this point of view, was to understand the conceptual system. Wittgenstein had pointed to the fact that concepts grow, but neither he, nor his followers, were very keen to explore the details of growth. To do so was to engage in historical research and at that point the connections with philosophy, for the philosopher, would seem understandably remote. The fact that philosophy might be a bogus activity and that it should be replaced by a study of the conceptual system as a real system would be difficult to acknowledge, or pursue, for those brought up within the traditions of philosophy.

Now, the idea that to understand concepts it is necessary to

trace their development, and thus their history, might be confused with two other forms of study about which most people know nothing. One is the history of language as it is conceived by the language departments of the universities, and the other is what is known as the history of ideas. However, neither of these is what is meant. The former is concerned with the history of language on a narrower basis than I have in mind. Its concerns are with phonetics, grammar and etymology and, on the whole, its grasp of language is over literary. It does not treat language as the point at which a whole society's grasp of reality can be understood. The history of ideas, on the other hand, is concerned with explaining the intellectual theories of previous societies, rather than charting the history of the concepts in which the whole life of a society, including its intellectual life, is articulated.

The significance of what I am advocating may not be apparent to most people. On the whole, people are not interested in what 'linguistic philosphy' might be or what the history of ideas is etc. Moreover, the point being made about investigating the history of the conceptual system may be too general to seem of any real importance. The potential importance of this line of thought will emerge more clearly in the chapters to follow which are concerned with the concept of art as a process in society. This is to say the importance is more likely to be apparent when a particular case is investigated. However, at a general level, and presupposing various thoughts already introduced, the importance of the discussion can be approached more directly. The theoretical traditions, the theories, the theoretical activities of our society, all appear to the mass of people as being remote from their lives. This produces a feeling of ignorance and inadequacy but one which is easily shrugged off for most people on the grounds that the activities, from which they are debarred, are all rather useless. There is the common feeling that they have very little to do with the real world as they experience it. There are virtues in this commonsense approach, because a

great deal of theoretical activity has been committed to the illusory validity of abstraction. However, the plain sense of ordinary people is insufficient to guarantee that they avoid being deceived. The crucial worry is that the conceptual system, the language in which people think and converse, may contain elements which have grown out of the society's theoretical and intellectual activities. There is the possibility that, in some areas, the society's language may be inadequate for dealing with the world, simply because it has grown out of false and artificial models as to how the world is. The possibility of having inadequate language tools for dealing correctly with the world, becomes more worrying when one reflects on the possibility that the artificial models, out of which the language has grown, may serve the practical needs of powerful groups in the society in the way of securing their position against challenge. Thus, there is the possibility that the common language used by most people confirms their subservience. To speak the language of the society is already for the masses to concede their inferiority. It is as an effective protest against this that the working class swear profusely. Every use of language is thereby tinged with hostility. In using the language there is conformity but in swearing an illusion of not conforming is created. People in the society are critical of most things that affect them but, on the whole, the language habits of the society are accepted uncritically, despite the fact that they might inculcate norms of procedure detrimental to the general welfare of the people.

What I am contending in this book is that art and philosophy (these activities are singled out from a range of comparable activities on the basis of my familiarity with them) give rise to conceptual practices which do run contrary to the interests of most people, and that all this has been happening without the majority of the people realising it. What has to be resisted is a sort of psychological conditioning process which the whole structure of society conspires to effect. It is a conditioning process which works not through overt propaganda (as in China) but through the consensus of conceptual habits.

This is not some idle speculation about the possibility that our whole language system is a smokescreen which hides our real life from us. As suggested earlier it would be futile to maintain this whilst at the same time presupposing the adequacy of a range of concepts in maintaining it. What I am suggesting is that limited areas of the conceptual system may work adversely against people's interests. It is my contention that the concept of art and attendant concepts work in this way. That this is so for any concept can only be properly uncovered by investigating the concept's social role and this involves uncovering its historical development. These possibilities occur to me, then, as a result of what I have concluded about the particular concept 'art' and its treatment in the philosophy of art (aesthetics). To understand this it is necessary to follow the remaining chapters.

The concept of art, which is to be explored, points to a life lived within society into which some are obsessively drawn but from which most derive no satisfaction. The attractions of the art life were attractions felt by myself as a student, in fact they were attractions which enabled me to commit myself to the life of a student. The attraction, as I experienced it, was one of entering into a superior existence. Superior, that is, to the existence of the mass of the people. The mass of the people were held to be besotted with the consumer society and, consequently, held to have no capacity to objectively comprehend their own lives. The people were seen as cattle in the fields, having no sense of the purpose for which they were there, or the manner in which they were being manipulated. On the other hand, to be in on the artistic life of the society was to walk in the company of seers.

This sounds a little like entering into religious experience, but in fact the experience was very different. The religious life, even at its most 'stuck up', does involve the adherent in some practical contact with others, for example tidying the churchyard with other parishioners, or transporting the elderly to church, or wallpapering for the disabled. However, the art life encouraged a superior distancing of the adherent

from others. A field was not something to enter and do things in, but a landscape to be stood outside of and observed. Similarly, with people at their occupations. Moreover, the life was one of sitting apart and reading, or walking in quiet rapture through the art gallery, or giving dignified attention in the concert hall. Much has happened in the arts over the last decade which may make this description of life in the arts seem unrepresentative. However, the situation was much as I have described, when I was first drawn into an awareness of artistic activity, and for those who know about these things the experiments of the last ten years have made very little difference to the way the art life is lived.

For those outside of this life the value of superiority built into it does, for the most part I suspect, pass them by unnoticed. Yet, at the same time, there must be some consciousness of the fact that knowledge of the art life is related to the social hierarchy of the society, and that not to have knowledge of it is always to be outside the accepted and established groups of power and status. Though, of course, to have the knowledge is not, thereby, to be within the appropriate social group. It tends to be the case that those most actively concerned with the public affairs of groups having considerable social status, have a good working knowledge of the arts, without being obsessively drawn into them, whereas it is amongst the more passive members of the group that the more obsessive devotee is found.

What concerned me from the very start with regard to the art life was how to justify the feeling of superior existence that went with it, and therefore, indirectly, how to explain the feeling of not being up to the highest activities of the society, felt by those outside it. It was the impossibility of finding a satisfactory justification which led to the historical reflections on the concept of art with which this book is concerned. It is on this basis, as I shall try to show, that the superiority of the art life emerges as bogus. It is at this point that resistance to art can begin.

This chapter serves both as an introduction to the methods

of enquiry subsequently employed throughout the book, and to what the book is about. Before proceeding to say something further about both methodology and the content of what is to follow I shall briefly summarise what has been advanced so far.

An examination of the concept of art, as a social and historical phenomenon, undermines the validity of abstract questions about the nature of art (the practice of abstraction is one itself requiring historical investigation). The examination also undermines the art life of our society as something which socially discriminates between different groups of people. The superiority of the art life of the society needs challenging not only because it cannot be justified, but more importantly because it is an integral part of the way the social structure operates against most people. For the challenge to be effective it must go hand in hand with an insistence on a concrete, historical method which directs itself to the world as an interacting movement of real processes (the conceptual life of the world included). In this way abstraction is opposed and generalisation only permitted where real processes exhibit empirically locatable similarity. It is because this book is about these sorts of questions that it can be said to be about art and philosophy.

Before going on to specify the content of the following chapters, there is one further point concerning the methodology which needs elaborating. In philosophy and other academic disciplines the question is often raised concerning the extent to which people determine their lives. Most people would not face this question as a general question, although they might from time to time ponder as to whether their own lives could have been lived differently. It is of obvious importance, in any attempt to assess the actions of people, that one has some awareness of the different interpretations that would arise from different beliefs about whether or not people do determine their lives. Here, of course, one has the possibility of raising the abstract questions, 'What is freedom?', and 'Does man have free will?'.

However, the question cannot be decided abstractly or even, necessarily, generally. It is only by looking and seeing whether particular people, or particular groups of people in particular situations, do determine their lives that one can discover the limited truth that those particular people did or did not. But, it might be asked, by what criteria does one decide whether or not people have determined what they have done? In dealing with the theoretical problem it is illuminating to posit a few, admittedly fanciful, cases.

Imagine the situation in which two adolescents, one male the other female, are captured by a mad scientist and subsequently forcibly injected with potent and effective aphrodisiacs (i.e. producing overwhelming amorous impulses). The adolescents are then unleashed upon each other whilst the scientist, from a concealed position, makes his observations. The outcome of the situation is that the adolescents copulate.

Secondly, imagine the situation in which two working-class adolescents (again one male, the other female) and both virgins, fall in love. The boy is sensitive to working-class, male chiding that the male asserts himself as male by deflowering the female virgin. The girl, on the other hand, is sensitive to the socially induced values that a girl cheapens herself by allowing pre-marital intercourse. The boy loves the girl but his object is to get her to consent to intercourse as quickly as possible, whereas the girl, in loving the boy, wishes to have intercourse with him, but wishes for marriage to precede it. The outcome is that one night, when darkness falls on the local golf course, the boy rapes the girl.

Comparing these two fictional situations it would be, for most people, non-controversial to assert that in the first case the adolescents did not determine what they did, whereas in the second case what they did was a mixture of their determining and being determined. It is not necessary to posit criteria for whatever it is that has determined the actions; the cases are self explanatory once looked at. Of course, the first case is much simpler than the second. This is because it is

far-fetched, whereas, the second case is, as our world goes, a possible situation. Clearly, in the first case, conscious determination of the copulation by the individuals involved has been by-passed. The example does not clarify in any way how this might be possible. It simply asserts that this is the case, and in order to enter into the spirit of the example it is necessary to credit the possibility. In the second case, we find the individuals manipulating each other and the environment in order to achieve what they seek. The girl's going out with the boy is a decision to act in accordance with the love she feels for him. It is also a decision to act in accordance with the plan to marry him. The girl, one can imagine, actively enters into heavy petting as something which is in accordance with her own impulses. She wants the boy to make love to her, which, of course, he does; she gets what she wants though not in the way that she wants. Similarly, the boy wants to make love to the girl, and does, but not as he would want to. He takes her by force, at the point at which she concedes to the social requirement of preserving virginity until marriage. The individuals are in their situation facing its problems, both as they are set by themselves, and by social pressures acting on them through the way the individuals have responded to these pressures. The individuals move through their problems determining the resolution of them and, thereby, determining things for each other.

No abstract theory of freedom is required to recognise the difference between these two situations, and to see that a different range of concepts is required in order to see and describe the difference. In the second case, as it is envisaged, we see the outcome results from a process in which the individuals determine and are determined. The outcome is the way these elements fuse. To understand the situation it is necessary to see the outcome as a result of a process in which the individuals make their reality, but make it as a response to various influences. It is because the situation is like this that it seems to be a situation with life breathed into it, whereas the first case is in comparison seemingly mechanical. Of course, the first situation is very sketchily presented and

as it stands it seems, perhaps, that the individuals blindly copulate. On the other hand, a more human face would have to be given to the situation if it was necessary to describe individuals seeking satisfactory copulation with each other, and solving problems so as to achieve this.

Whether or not, in any analysis we conduct, we locate human beings making their reality is an empirical matter (i.e. a matter of how things are or are not). Moreover, the extent to which individuals are to be found determining their lives is again an empirical matter; there may be, in any given social situation, more or less external factors influencing or determining the outcome. However, what is important, from the standpoint of proposing a method of enquiry, is that the situations, in which people are to be found actively determining their reality, should be articulated in accordance with their activity as determining agents. This is easy enough to say but more difficult to understand with regard to its implications. In fact, the implications carry all the way back to ideas broached earlier about essences and processes. The point is that where people can be credited with a determining role then the situations they are passing through, are ones they are making, and outcomes of the making process are continuously being modified by the way the individual relates himself to them. There are no static moments, no essential slices, life is, for those determining it, continuous process. There is no completion, no having fixed things without continuing and withdrawable acceptance that things are fixed.

This, no doubt, sounds very enigmatic and again illustrations are helpful. The world of advertisements tends to induce the idea that a certain feeling of style and mood could be what one constantly and continuously would feel if only one possessed the requisite objects advertised. However, a moment's reflection, on the acquisition and ownership of advertised objects convincingly shows that those objects can never be enjoyed as they seem to be in the advertiser's image of them. The situation when one possesses an object is

continuous and not static. The rest of one's life takes one away from the static contemplation of the objects. The meaning the objects have for one is transformed by the actual experiences which take place around them (e.g. the site of a major family quarrel, the room in which one spent an evening of terror believing there was a marauder outside). Moreover, the objects themselves are changing. Gradually they lose their lustre and a constant struggle has to be entered into in order to preserve them in their original state. None of these transformative factors are included in the advertiser's image of life with those objects; one is supposed to enjoy the eternal smile, the eternal feeling of being cool.

However, life goes on, its various bits interact and connect, and one is at the centre of one's life experience continuously shaping and having before one the continuous, undeniable possibility of being able to shape it differently. It is this sense of the fluidity, in the existence of those who are involved in determining their lives, which has to be rendered in any account of those lives. Where such an account is appropriate the lives cannot be presented as a finality or as conforming to an essence, but the fluid, ongoing, open texture of the lives needs to be gestured to. In this way the lives do not appear as conforming to a neat, manageable formula but appear rather as the necessary, rather sprawling affairs that they are: interconnecting process constantly being affirmed and rejected from a range of possible processes. The family could have bought a new car, but it decided on a swimming pool instead. The family beside the pool is not the finality 'aquatic sun worshippers'. It is the group that knows it pays for its choice by limitations on its freedom of action. The possible car is now not possible. The illusory essence that went with it cannot even now be sought. The breeze beside the pool is invariably chilly, the water constantly needs cleansing, the water antics increasingly become stale as they fit into the habitual family patterns, and all of this, as complex as it is, has to relate to all the other moments in the lives involved. Thus, the husband feels doomed to

continue in a job, which bores him, to repay his loan, which financed the pool plus all the other similar loans that his dedication to the job has secured. The wife's irritability increases as the thoughtless abandon, which the enjoyment of the pool is meant to induce, leads to wet, muddy feet tramping all over the house, which other concepts of how the family's existence should be has kept the wife cleaning throughout the day. Such lives sprawl, open-ended in many directions, and it is this untidy, inexhaustible set of interconnections that an account of people making their lives must get to.

With this said, I can return to the project of specifying the structure of this book as it is to unfold. What is to follow is meant as falling under the methodological recommendation with which this chapter is, in part, concerned. However, this is not always carried through to the letter. The amount of detail which has to be included in order to do justice to people's determining their reality is clearly immense. The chapter to follow, which is concerned with the falseness of an abstract understanding of art and which, to counteract this, produces a sketch of the history of the concept, is, when compared with the full possibilities of particularity and specificity, very general in character. However, a huge volume would have been necessary to present the arguments otherwise, and apart from feeling ill-equipped to do this, to have done so would have unduly increased the difficulties of reaching the required audience. At the same time the validity of the, by comparison, general analysis, conducted needs to be measured against what is known at a more particular and specific level. Should the analysis not measure up to the way particular lives were lived within their group settings, then the analysis would be inadequate. It is, of course, my view that this is not so.

The chapter on the concept of art makes much of connections between art and the bourgeoisie and this requires some advance explanation. To begin with the term 'bourgeoisie' is not used by the average person. It is a term used more now

than it was, but for most people it is regarded as a piece of jargon used by revolutionaries, like 'bread', meaning money, is regarded as a piece of jargon used by hippies. Setting aside these associations and limitations on use, the term, in the context of this book, is used to mean those various historical groups who have used capital to secure private profit and who have, for the most part, achieved this by securing for themselves ownership of the society's various means of production. The term is used not only to apply to those who own the means of production, for the purposes of the production of private profit, but also to those closely related to such a social group in the society's power structure, and whose net social activity adds up to assisting and preserving such a social structure. This might seem to some people revolutionary talk, but, in fact, nothing of this sort has been advanced. If most people stop to think for a moment it will become obvious to them that their lives are neither seriously employed in making large profits out of personal capital, nor in securing ownership of and profiting thereby from the means of production (e.g. ICI, Watney Mann etc.). To realise this is to realise that there must be others who do, even if they are not personally known to one, and that there must be still others closely dependent for power and prestige on the welfare of this group. Despite these disavowals, the chapter on the concept of art will seem Marxist in character to those who have any concept of such matters. However, my views on the concept of art are not Marxist and it is the function of the third chapter to demonstrate this.

In terms of the readership in which I am interested the third chapter must be the most uninteresting of the book as it is concerned with trying to understanding the practice of Marxist writers on art. The point of trying to achieve this understanding is to disassociate my own analysis from the Marxist label and also to show how Marxist conceptions of, and uses of, art are paradoxically bourgeois in character. If this chapter has any chance of appealing to the broad mass of the people it is to those people, living in societies which

regard themselves as Marxist, that it is directed. Such people are as much duped and adversely served by being measured socially through their acceptance, or otherwise, of the ideology of art as are their Western counterparts. The people in Marxist societies are assured that they are saved from the corruption of bourgeois art by a truly revolutionary, working-class art. The point I shall make in contradistinction is that this latter notion is a contradiction in terms, because the very concept of *art* is a bourgeois classificatory practice.

The final chapter of the book is intended as a detailed study of how, in our society, something becomes art. It is concerned to show how jazz as a form of musical activity existing outside of artistic activity is gradually sucked into the sphere of art and is as a consequence killed off as the thing it was. As such this chapter acts as a warning to the whole rhythm and blues movement and its various off-shoots. More than this though, the analysis is intended as exemplifying the methods which have been the subject matter of these introductory remarks. Thus, a detailed attempt is made to show how the question as to whether or not jazz is art, is in no way settled by theoretical, abstract considerations, but results from the interconnecting of complicated social processes, processes which can be significantly linked to the general remarks made about particular social processes in the second chapter. Crudely put, the point made is that as jazz becomes part of bourgeois experience so it becomes art, and as it becomes art so it becomes detached from the interest and desires of the broad mass of the people, whereas before this transformation took place this was not so. It is on the basis of this chapter that the idea of a revolt against art, which gets its credence from earlier chapters, gains its impetus.

As a sort of footnote to this chapter I should like to point out that the ideas contained in it are not peculiar to myself. There are other sources for acquiring them, although the other contexts, as I am aware of them, are not written with the mases in mind as readers. Two books I would particularly

recommend in this connection are K. Marx *German Ideology* and J.-P. Sartre *The Problem of Method*. Personally I have profited from these two books more than most.

Chapter Two

CORRECTING MISTAKEN IDEAS ABOUT ART AND CULTURE

We can imagine in a couple of hundred years from now a situation in which people still continue to engage in the cultural, artistic life. It is a feature of this kind of life as we know it at present that it concerns itself with the history of cultural activities. If the future situation was comparable we would find that the people living then would have formed some conception of twentieth century art. Suppose, then, that they arrived at their view of the art of our period after having asked themselves what twentieth century works there were that were distinctive of the period and, further, what works there were that they liked. Suppose they came to the following rather startling conclusions. They decided that what, for our society, constitutes the great artists, writers, poets and composers e.g. Picasso, George Bernard Shaw, Joseph Conrad, Walt Whitman, Elgar, etc. are not to be so regarded by them. They hold, let us suppose, that the great works of art of the twentieth century consist of things like cranes, gasometers, farm machinery and washing machines, and that the revered names in the world of the arts include Elvis Presley, Ivor Novello, Barbara Cartland, Patience Strong, Ben Travers, the Osmonds etc. Most people in our society now, whether interested in the arts or not, will recognise that some reversal of the normal ordering system would have taken place for this eventuality to come about.

This projected future is, of course, artifically conceived.

The process, whereby something is established as a work of art, or someone is established as an important name in the arts, does not depend on people consciously getting together, at a particular time, and asking themselves if certain works, and people, measure up to certain standards. Within our own society there exist traditional assumptions about which objects are art objects, and which persons are accounted great artists. These traditional assumptions constitute a more or less commonly shared knowledge. The educational forms of the society ensure that most people know that Shakespeare is a great writer, and Chopin a great composer. The possession of a more detailed knowledge about what works of art and artists there are depends largely, for the individual, on whether or not his social background is one of engagement with the arts (if so the family is likely to be well to do, of some social status, more bourgeois than not) and depends, also, on the extent to which the individual has succeeded within the educational forms of the society. Having had the appropriate educational success, or having the appropriate social background, means that you will know Duchamp is a famous twentieth century artist, Berméjo a competent fifteenth century Spanish painter, John Cage a controversial twentieth century musical personality. Most of those, for whom this book is intended, will not know this.

Something to remember, therefore, is the formative influence of traditional assumptions. The predicted future is artificial because it neglects to locate these traditional assumptions at work in the society. The people to come would not have to wake up one morning and decide what was, and what was not, the artistic achievements of the twentieth century. The question would already be settled. It might be possible to alter or modify these traditions to some extent (after all a sense of history is transmitted by passing through societies and this cannot be solely a passive process; something happens to traditions on route) but it would be impossible to ignore them altogether. We cannot, now, decide afresh what constitutes the art of the eighteenth

century, because this is already decided, and so would be the art of the twentieth century for people of the twenty-second century.

However, supposing these suppositions about the future did come to pass, we might wonder whether or not the people to come had made a mistake about the art of the twentieth century. Alternatively, we might suppose that we were, or our society was, mistaken. In the latter case how might we explain this mistake? A possible explanation might go as follows: The traditional assumptions about what is art naturally are influential. People in the society are instructed in these traditions just as they are taught other traditions of the society e.g. the history of the society's wars and battles. These traditions though are acted upon, and the contemporary additions to the traditions, which are passed on to subsequent generations as part of the overall, ongoing tradition, are made. However, additions to the tradition are not achieved as one might suppose new members of MENSA (the club for people of high IQ scores), or new members of the black belt class in judo, are added. The process involved, in art, is not one of a sifting by experts, but one of innumerable social arrangements interacting with each other. The additions are not simply the result of rational deliberation. In contemporary society, the social processes involved constitute one of the businesses or industries of the society.

We might compare, here, the way in which something becomes established as a work of art, or the way someone becomes established as a great artist, or great critic, with the way in which a commercial product establishes itself as successful. For instance, the pre-packed, sliced loaf which we all eat would generally be accounted inferior to the cottage industry-type loaf, which these days is not generally available. The modern loaf has replaced the apparently more desired, older loaf, not on the basis of its acknowledged superiority as bread, but as the result of various other social factors, including highly competitive pricing, superior distribution services, the thinness of the slices and the economy

therein, the addition of preservatives avoiding staleness etc. It might be true that people would have preferred the older loaf to have had all the advantages of the modern loaf, but, quite apart from their preferences, what they put up with is something with these advantages, looking like bread, but tasting very unlike it. In other words, many factors explain the success of the modern loaf, but one factor is not part of the explanation, namely, people having rationally decided which bread they liked consuming the most.

We might suggest that extensions to the art tradition are the outcome of a certain class situation in the society, rather than something springing from rational deliberation. Within contemporary society the sustaining of the art tradition and growth within it, stem from social processes within upper-middle-class or bourgeois society. For example, in the schools the 'cultural' values which the educational system tries to inculcate are not those of the majority of the pupils, or of their social background. The 'cultural' experience commended to the pupils is 'high-culture'. 'High-culture' is, as something actively accepted and welcomed, an integral part of bourgeois life. Its obvious, typical, social contexts include Covent Garden, The National Film Theatre, Royal Festival Hall, The Old Vic, The Tate Gallery, Sadlers Wells; contexts in which artistic, 'high-cultural' events take place. Its less obvious contexts include private Bond Street galleries, established publishing houses, prestige art schools, literature departments of universities, so called 'quality newspapers', businesses etc. It seems clear that although these lists are only the tips of very considerable icebergs of exclusive social activity, they do signify whole worlds of social experience with which most people have had very little direct or intimate acquaintance. At this point we might try to explain our mistake concerning art, remembering that, for the moment, it is being assumed that those fictional people of the future might be right. We might say that the mental set (i.e. frame of mind) of the predominating class in the artistic area (the bourgeoisie) prevents it from seeing what is of true value.

This suggestion is not preposterous. Analogously, it is argued by the cultural establishment that it is because of their background that the working-class prefer, whatever it is that they do prefer on the T.V. to say, a T.V. production of *Waiting for Godot* (a rather obscure, 'high-cultural' drama, written by Samuel Beckett). In other words it is argued that a working-class audience cannot tell the difference between the good and the bad and this is because of their socially induced frame of mind. The claim is that their class position is their limitation. Well, for the sake of argument, the argument could be turned around. We might add weight to this argument by saying the involved, special language in which the world of art is discussed is a smoke-screen conferring a special mystique, or aura, about this aspect of bourgeois life. The class speaks of its preference being 'art'. The language itself confers a special status on what is enjoyed.

Many people, in the history of writing about art, have come to this conclusion. Tolstoy, the Russian writer, concluded this. (Tolstoy, *What is Art*.) For him, the art of his own society was only the art of, what he called, the upper classes. He disparaged this art and made a distinction between it and *real art* (real art being that which was not accepted in his own society as art). In fact it is tempting, in explaining the alleged mistake on the basis of class bias, to try to resurrect a category of 'real art' which is not the accepted art of the society. However, what I wish to bring out is that, though we have uncovered some of the factors necessary to an understanding of the concept of art, in treating the discrepant concepts of art, between the twentieth century and the twenty-second century, as indicating a mistake, we have gone wrong at a methodological level. The alleged mistake could not exist, because there is no category of true art apart from the established category.

To try to bring out the implications of this I refer to something Marx wrote in his early work the *Economic and Philosophical Manuscripts of 1844*.

Religion, family, state, law, morality, science, art, etc., are only par-
ticular modes of production, and fall under its general law. The
positive transcendence of private property, as the appropriation of
human life, is therefore the positive transcendence of all estrange-
ment—that is to say, the return of man from religion, family, state,
etc., to his human i.e. social existence. (pp. 102-3 Lawrence Wishart
London 59 edition.)

Commentators on what Marx meant, in his various writ-
ings, think it obvious that, in this passage, Marx was not
foreseeing a future in which art would no longer exist
(perhaps had been abolished) as he certainly was foreseeing
a future in which religion, the insular family, the State and
Law would not exist. This interpretation of Marx is quite
correct. For Marx art is a universal, perennial feature of
human reality, whereas the *State* is, in comparison, tempor-
ary. Art is a basic category of a human world, for Marx like,
say, language.

It is my suggestion that to understand the concept of art it
needs to be treated as Marx treats religion, State and Law. It
is my view that Marx's own treatment of art is methodologi-
cally unsound. Marx deals with the State, for example, in an
anti-essentialist manner; his method is historical. For Marx
'the State' is a phrase used to refer to an assortment of
institutions within society. These institutions are held to
conform to certain assertions about them, such as their being
controlled by the ruling class and their not emerging until the
division of society into distinct social classes, and their acting
in the interests of the established social order. These are
empirically observed facts about how the institutions of the
State were created, and how they have functioned histori-
cally. However, these facts about the State are not presented
by Marx as accidental facts, or facts that could have easily
been otherwise. They are part of a story in which institutions
constitute some of the characters and, like characters in
stories, their development grows naturally, not accidentally,
out of the total, natural and social situation. However, the
remarks Marx made about the State are not remarks to which

there can be no exceptions: they are not part of a useless attempt to *define* what the State is, or to distil some essence out of the notion. The State, then, as an historical phenomenon, can, depending upon social circumstances, come and go. It is not a basic fact of human life without which human life would be unimaginable. The State is historical; it has a clearly detectable beginning, and it is possible that the social need for it could lapse into disuse. To understand the State, for Marx, one has to follow the story of its development. When we turn to Marx's treatment of art the historical method, he uses elsewhere, disappears. Art is, for Marx, some fundamental human dimension. This commitment to art, as something basic and universal, leads Marx to positions at odds with the facts. I shall have more to say about this in the next chapter.

Something which paves the way for an historical treatment of the concept 'art', is to draw attention to a distinction between the category of art and, what might appear to be, another category with which it could be confused. It is quite clear that the enormous number of people, who have no interest in the arts, are nevertheless interested in music (e.g. Radio 1), drama (T.V. plays), cinema (*Jaws*), dancing (Ballroom and Disco), novels (thrillers and romances) etc. This list of activities indicates a general category of activities which includes various things but, also, excludes others. For instance, it excludes football and darts, but includes musicals and painting. This general category is not the category of art, although the category of art lies within it, thus, for music, we could give the example of Bach's Partitas, for drama Shakespeare's plays, for cinema *Les Biches* etc. We have, then, a general category within which reside various, distinct subcategories. Having clarified this much, we might go on to question whether the claims that art is universal and perennial are invalidly deduced from the belief that this more general category is universal. However, even this belief is far from certain, for though we might feel confident that, in most societies there have been, we could identify people

engaging in dancing, making music and painting, this is not necessarily the same thing as being able to identify the more general category. To identify the more general category, we should need to be satisfied that the societies being investigated did, in fact, divide their worlds up in this way. No matter how the problem is solved, it is clear that, in our own society, we do have a sense of the general category as distinct from the category of art.

If art is a sub-category of this more general category, why is this? It seems obvious from the ways these notions are used that the distinction has to do with different senses of value. If one is the kind of person who finds it natural to say of a novel one has particularly enjoyed that it is a work of art, then, within a standard setting, one is saying that the novel is of greater value than other novels, from which the art categorisation has been withheld. The sub-category *art*, within the more general category, is kept alive, as a distinct form of social existence, by those who believe its activities are superior to other activities within the general category. But, are these beliefs correct? We are, then, back with the earlier question in a different form. Earlier we were asking whether or not what is picked out as art, in our society, might be the wrong collection of things, now we are asking whether it is true to say that what is art is superior to what is of the general category, but not art. In the history of writing about art innumerable theories have been put forward to try to establish art as superior activity. Sometimes the attempt has been made to show that concern with art is superior to concern with things that would not fall within the general category, for example science, at other times the attempt has been made to show there is a cultural divide within the general category between what is high and superior, and what is low and inferior. For the most part, these theories have attempted to do these things by producing a definition of art which, of itself, would mean that art was superior. The trouble with the theorising has been that there have been a mass of contradictory theories. For every theory proposed there

have been developments within art which have produced counter-examples, and there have subsequently been counter-theories and new theories proposed. The net outcome of all this activity has not been a gradual approach towards the truth of the matter, but rather a source of employment for critics, aestheticians, philosophers and the literary establishment. In other words, the question of understanding the belief in the superiority of art and, by implication, the question as to whether a society could be mistaken as to what was and was not art, are not questions on which the theorising within art throws much light. If, on the other hand, we take on a social, historical perspective, in terms of artistic activity as a whole, we begin to uncover a startling explanation.

Before actually moving into the historical material I will set out, in a formal way, the pattern of the historical explanation to be offered. This might seem to make for unnecessary complication but, when followed, it does help to keep the overall strategy in view, which might otherwise disappear. The pattern of the explanation to be offered is, then, as follows:

In our culture (type of society) there is a heading A (the concept A), which heads the grouping a-h (the grouping a-h is not rigidly set, as there is some dispute, in the culture, as to whether or not i and j are of the grouping). Moreover, we have another heading B, which heads the grouping p-r and another heading C, heading the grouping s-v. In the culture it is held that A, B and C are mutually exclusive categories. In earlier societies, in the eighteenth century, we find in operation some headings, which as words have historical links with some of the words for the headings in our own culture. Two such headings I will call A_1 and C_1; this is to allow that, as headings, there may be differences between them and our own headings, but to allow that as words, there are links. In fact the things grouped, under these headings, are to some extent discrepant with our own groups. Thus A_1 heads a-f and C_1 t-v. When we

go back to the medieval or ancient worlds we can find conceptual structures corresponding, roughly, to the following descriptions. Thus, there are headings having historical word-links with our heading A, which head distinct and mutually exclusive categories. We find, what we might call A_2 and A_3 headings co-existing though in opposition to each other. A_2 heads a-c and p and and s-v and x, whereas A_3 heads d-g and k-o and y and z. The range of terms a-z are, at least, word-linked throughout the range of periods. The obvious question, to which such discovered structures lead, is 'Are A, A_1, A_2 and A_3 identical?'. Now, this question cannot be settled by ascertaining mere formal correspondences, or, if it could, it would be obvious that A_1, A_2 and A_3 are not identical with A. When concepts are formalised, as has just been done, one must be careful not to forget that these groupings are lived. To remember this is to know that identity encompasses change. Thus, a person in growing older is the same person though changed. This is because a person is an identifiable process rather than a fixed essence, which has always to be the same. However, to admit that the groupings are lived does not entail that organic connections (as they might be called) establish identity. An organism can split so as to abolish itself and so produce independent organisms, or an organism can keep its identity whilst producing offspring as does the mother with her child. The question of identity of conceptual practices is very much the question of whether social groups could, without serious disorientation, slip into the conceptual practices of other social groups. What, then, would make the headings different would not be formal discrepancy, but rather the impossibility of living one network of conceptual relations as another. Where there is no way of living one's own network inside the network of a discrepant culture, then there we touch the limits of our conceptual life.

In appropriate historical circumstances, a culture may absorb a network, which is in fact alien, by a transformation of it. Where there are no appropriate historical circumstances

a culture may be content to exhibit the discrepant network as alien. On this basis we probably believe (or would probably believe if we thought about it) that we could slip into the Ancient Greek world and yet retain our conceptual identity, whereas, we would be more hesitant about our capacity to do this in uncontaminated, aboriginal society (especially if we knew something about the way in which the aborigines divided up their world). The historical data, therefore, needs to be set out clearly, that is, free from the historical transformations that may have taken place (transformations which of themselves can make divergent data appear similar). Subsequently, one has to decide whether or not one network of categories (one process of classification) could be lived as another. In this way it is possible to pronounce on the identity or otherwise of classificatory processes as given through the historical perspective. What, then, of the data?

It has been shown that it is only in the seventeenth and eighteenth centuries that the modern system of the arts emerges. E.g. P.O. Kristeller 'The Modern System of the Arts' A study in the History of Aesthetics. *Journal of the History of Ideas*, Vol. XII (Oct 1951) and Vol. XIII (January 1952). In the ancient world there were two categories which modern scholarship calls the *liberal arts* and the *imitative arts*. Arranged under the heading, the *liberal arts* were the activities grammar, rhetoric, dialectic, arithmetic, geometry, astronomy, music, medicine and architecture, whereas under the heading of the *imitative arts* were included the activities of poetry, sculpture, music, sophistry, the use of mirrors and magic tricks. In fact, for the ancient world any activity that was covered by a set of rules for doing it was known as an art. It is fairly obvious, therefore, that words, in the ancient world, that can be linked to our word 'art' are doing a different job to that done by our word. Of course, in ordinary language many activities, which require great skill if they are to be done well, and especially so if some high degree of manual dexterity is called for, are referred to as arts. However, this notion is not identical with the notion of

art given to us by the high-culture of the society. The ancient world's notion of art is not confined to activities requiring a high order of manual skill and there are, obviously, enormous divergencies between their concept and our 'high-culture' notion of art (this latter notion is, of course, the one with which this discussion is concerned).

The modern concept of art is also noticeably absent throughout the Middle Ages. Kristeller, in his article makes the point clear,

> The very concept of 'art' retained the same comprehensive meaning it had possessed in antiquity, and the same connotation that it was teachable. And the term *artista* coined in the Middle Ages indicated either the craftsman or the student of the liberal arts. Neither for Dante nor for Aquinas has the term Art the meaning we associate with it, and it has been emphasised or admitted that for Aquinas shoe-making and cooking, juggling, grammar and arithmetic are no less and in no other sense *artes* than painting and sculpture, poetry and music, which latter are never grouped together, not even as imitative arts.

Medieval theories about the world were heavily dependant upon the authority of the Ancients (although ancient theories were transformed to fit the medieval sense of spirituality). One important source for what medieval theorists wanted to say about art was Cicero's pupil Marius Victorinus. In Victorinus, the broad concept of art indicated by the Kristeller quotations is in operation. For him the classifying of precious stones and the science of population statistics are both arts. In the Middle Ages, there are theories about what modern scholarship calls *beauty* (decor, pulchrum etc.), but our concept of art is not the same as these medieval concepts. These so called concepts of beauty, in the main, concern someone or something being in accordance with one's or its nature. Thus, for everything there is, it is held that there is some essence it has, or some function it is to fulfil, and the more the properties of the thing, or person, contribute to this fulfilment of its nature so the concepts of *decor* and *pulchrum* apply. This has little to do with any modern

concept of *beauty* and even less to do with the vast variety within the modern concept of art.

It is Kristeller's contention that the same holds for the Renaissance. Though Leonardo gives us something looking like the modern system of the arts this is only so with important reservations. For instance, architecture is not listed by him as an art, whilst he treats painting and mathematics as activities of the same kind. For another Renaissance figure, Castiglione, there was no real distinction between poetry, music and painting on the one hand and fencing, horse riding, classical learning, the collecting of coins and medals and natural curiosities on the other.

The evidence, here, for the systems of classification employed by previous societies is only of limited value, in so far as it is mainly derived from theoretical sources. The assumption behind the evidence is that the pronouncements by such figures as Leonardo and Castiglione, do tell us how the people in Europe during the Renaissance period classified their world. However, the actual data (i.e. the living community) is not available and, therefore, the business of finding out, as well as we are able, is heavily dependant on such sources. Despite this it should not be forgotten that what is available are contemporaneous attempts at theorising about a society's practices, and they are as likely to be at variance with what goes on as are our own theoretical writings about our own activities. There are, of course, certain cross-checks that can be made. For instance, from what we know of the history of archeology we can be certain that within the worlds we have been describing, we would find no buildings fulfilling identical functions to the large contemporary art gallery or concert hall, and from what we know of the history of political institutions we know we would not find, in these earlier societies, departments of government devoted to the promotion of the arts. Moreover, the educational processes of these societies have no institutionalised means for making our educational division between the arts and the sciences. The societies involved do not have our concepts for making

the distinction, and, consequently, they have no problem comparable to our own, of bridging the gap.

It is Kristeller's view that the ground is prepared for the modern system of the arts by the emancipation of the natural sciences. Kristeller says,

> A point by point examination of the claim of the ancients and moderns in the various fields led to the insight that in certain fields, where everything depends upon mathematical calculation and the accumulation of knowledge, the progress of the moderns over the ancients can be clearly demonstrated, whereas in certain other fields which depend upon individual talent and on the taste of the critic, the relative merits of the ancient and moderns cannot be so clearly established but may be subject to controversy.
>
> Thus the ground is prepared for the first time for a clear distinction between the arts and the sciences, a distinction absent from ancient, medieval or Renaissance discussions of such subjects even though the same words were used.

The general point is, then, that the conceptual system as it concerns art from the seventeenth century onwards is of a piece, but is decreasingly locatable the further back we go from the seventeenth century. There is, naturally enough, an organic connection between what Kristeller calls the modern system of the arts and what precedes it, but this, in itself, fails to guarantee identity, because what has to be explored is what is being done with a conceptual system, what its function is, and the character of its grip on social consciousness. What is clear, at this point, is that there is an historical divide around the seventeenth century between what went before and what comes after. From the seventeenth century onwards European society increasingly classifies under the heading 'art' the activities which our own society would recognise as falling under that heading. Before this time the system of classification is clearly different.

What then explains this historical division? I suggest the historical explanation resides in those factors which give rise to the modern period. These include the growing dominance of the bourgeoisie over against the landed aristocracy and

court circles, the emergence of science and also, importantly, the link between the two. It is this complex, which breaks down the older, conceptual habits, and gives rise to new and distinct forms of life. The emergence of the scientific attitude and the emergence of the new economic system were very intertwined. The early, primary centre of the new scientific mode, The Dutch Republic, was also the early centre of bourgeois, mercantile activity, and both were interconnected theoretically and practically. Both these enterprises came under similar repressive pressure from the old, social order. This social order adapted or transformed itself and its conceptual habits so as to meet the challenge. As one part of the old form of life had been transformed by the bourgeoisie (i.e. what has come to be scientific activities) so the aristocracy turned to other parts of the old life form, which had been less uniquely molested, and turned them into distinct and new forms of life, which were distinct and new in so far as they were set against, and in opposition to, the distinct life style of the bourgeoisie. Art was the invention of the aristocracy.

Adkins Richardson summarises the point,

> It can be argued to considerable effect that the very notion of absolute standards of decorum in life was already a response to the incursions of a 'patent nobility' (drawn from the wealthy middle class) upon the ancient privileges of the nobility of gentle birth. (J. Adkins Richardson 'Illustration and Art', in *British Journal of Aesthetics*, 1971)

This point is very much based on the evidence assembled in Arnold Hauser's large *The Social History of Art* (London, 1962).

The contrast between the older forms of life and the newly emerging forms is made by Adkins Richardson in discussing Leonardo.

> For him the suggestion that a panel painting by a routinely competent artisan might not be art would have been meaningless. Such

transcendent, exclusive concepts of value did not exist for the
Quattrocento ... Art was invented by a later industrial age.

The significance of the new art concept was that of
elevating part of the old form of life into an object of
irrational reverence. This is to say, a whole set of 'word-
games', a whole vocabulary to talk about something called
'art', was developed, whereby what was distinctive of the
aristocratic life was held up as being of objectively superior
status. To enter into this form of life was to be concerned
with elevated and superior activity. In fact this was not the
case, but this was the ideological point. The scientific life was
concerned with the advancement of knowledge, but in oppo-
sition to this the artistic life, as it was now conceived of,
contested for the status of a form of knowledge. Thus, the
early theories of art (art in the modern sense) coupled art
with truth, and the truth which art was directed to celebrate
in order to be art, was very concrete and very much known,
namely, the old cosmological and social order, which the
growing dominance of bourgeois trends was threatening and
would soon overthrow.

At this point, art as a concept was reasonably coherent and
cohesive despite (a) it being the case that what passed for art
was that which corresponded with a false and socially
redundant view of the world, and despite (b) the fact that the
label 'art' was offered as an objective and verifiable measure
of worth when it was nothing of the sort. The established
ideology of an under siege, divided amongst itself (e.g. the
gap between town, the court and country) and, therefore,
warring feudal order presented itself, and the society at large,
with artistic activity as of the highest, most absolute form of
social and individual aspiration. The revolutionary class,
through whose activity came about the normalisation of
bourgeois social relations (e.g. wage labour, the labour
market, the ownership of the means of production) and
which contains persons having status on the basis of the older
feudal set-up, in its aspiration to be the ruling class has the

aspiration to take over the life of the ruling class. However, as the life of the ruling class was lived in opposition to the life of a growing, dominant bourgeoisie, so the life of the ruling class could not be assimilated in its particularity by the ascendant class. Therefore, the general desire by the revolutionary class for art becomes the concrete project of elevating certain bourgeois practices to the status of art, and transforming (if only by means of theoretical activity — altering the theories about the nature of art) aristocratic instances of art into manageable, bourgeois proportions.

This movement is reflected in changes which occur in aesthetic theory during the seventeenth and eighteenth centuries. The theories, which accommodate the art concept to the general mental set of the bourgeoisie, are those which make beauty (as a concept having particular relevance to art) a matter of taste, i.e. a matter of how human beings happen to be constituted. Thus, beauty is no longer thought of in terms of truth (i.e. the extent to which the work of art reflects or represents the established social structure) but is thought of in terms of the presence or absence of a psychological response, often identified in the theories as *pleasure*. If art is thought of as some abstract category, in need of theoretical definition, then the various theories, in the history of aesthetics, are simply assessed from the point of view of their adequacy, but in wrongly concentrating on art as an abstract problem, we miss the practical strategy behind the formulation of such theories. The insistence on art as being ultimately a matter of taste, rather than an accurate representation of a certain social order, is the move required to allow, into the category of art, the degree of flexibility whereby the bourgeoisie, as the ruling class, can assimilate it. Bourgeois painting, writing etc., do not count as art on aristocratic criteria, but they do as the bourgeoisie assimilate and transform the life style of the aristocracy. Such is the fundamental, practical opposition between the theorists Hume, Burke, Dubos and Bonhours on the one hand and Boileau, Reynolds and Shaftesbury on the other. From this point onwards the

development of art is tied to the development of the bour-
geoisie. This latter development is not a smooth progression,
but, in itself, encompasses many revolutionary changes
connected with technological revolutions and the way they
are experienced socially; this complex movement is deeply
embedded in the unfolding of the category of art.

A theory of taste, a matter of the occurrence or non-
occurrence of pleasure, does not hold a dominant position
for long. As bourgeois social relations become the normal
form of social relations, so the degree of leverage against the
aristocratic theories of art becomes unnecessary. What is
subsequently required are theories to add authority to the
particular, evolving, mental set of the new ruling class.
Crudely speaking, this takes two basic forms (1) the insis-
tence on form and the knowledge of form and (2) the
insistence on individualism, basically Romanticism. The
primary theory of taste does not disappear altogether. It
remains as a way of explaining interest in art for those not
actively obsessed by the category. Up to a point it is the way
the more scientifically oriented members of the bourgeoisie
scientifically (psychologically) account for the life form in
which they participate to a limited degree. It is the tolerated,
non-revolutionary, bourgeois opposition to the actual
historical character of bourgeois society which creates the
authoritative justifications for the bourgeois 'cultural' life as
a high ideal.

The bourgeoisie as a whole is not fulfilled by the product-
ive processes of Capitalist society. The growth of applied
science, the increase in mechanisation, the objective of
production being the accumulation of profits, the fragmenta-
tion and dehumanising aspects of the production process
(both for wage earners and those who own the means of
production, including those who assist them) all add up,
within the bourgeoisie itself, to an impulse to deny, escape
from, or compensate for the economic base upon which
bourgeois, material security is dependent. The legacy of the
older form of society is one of the possibility of a great and

absolute, spiritual fulfilment through the social organisation of the society. This is not to say such fulfilment was possible within the older society, but its ideology offered this as the point of such a society. This is an active tradition within bourgeois society and one which, quite apart from the sense of unfulfilment offered by the base of the society, is one the society would like to square with that base, as to do so would be to propagandise for social cohesiveness and pulling together. In other words, the social need to make something out of the 'cultural life' is not some mythical quality of human-ness expressing itself in the midst of bourgeois dehumanisation, but rather the expression of culturally conditioned expectations. Art, as we know it now, is the result of these various processes working themselves out.

As experienced in contemporary society art is a form of life, a conceptual system, which is lived within the bourgeois setting. It is from this setting that the art process emanates, and its life-enhancing ripples do not extend far beyond the interests of this social class. There are institutional attempts to enrol other sections of the society in the form of life, but they are resisted. This resistance may be interpreted as proletarian resistance. The concept of art is not just a heading, but something which enters into and structures judgement. To say of something that it is a work of art is not merely to say it is, for instance, of the form music and therefore art, for we know the mass area of musical consumption, in our society, has nothing to do with the sphere of art. It is the social area, in which the instance is taken up, that confers the status of art upon the instance. Once taken up and established something remains as an instance of art because it is established, because it constitutes part of the traditions of the category. The judgement that something is art assigns a value to it. The value is offered in bourgeois practice as being objectively determinable, and the constant search for definitional theories has been the attempt to rationalise this judgement. However, these judgements are without rationale. At best, the theories construct irrational

reverence for activities which suit bourgeois needs, but not the universal ones the theories make out they do. Art is a fetish. As this is so, so mystification becomes part of the concept of art. From outside the form of life, one can say art is nothing over and above what the bourgeoisie classifies as art, that is its meaning, but, from inside the category, such a thought is intolerable because it dismantles the beliefs that go with entering into the activities of the category. The beliefs posit the objective superiority of those things singled out as art and, thereby, the superiority of the form of life which celebrates them, and the social group which is implicated. It is out of this sort of logical mystification that the category of art emerged in the first place, that is, as an attempt on the part of the old order in society to make out its life was somehow committed to a superior form of knowledge.

Therefore, we can say that art is a highly specific form of life, which is identifiable only within specific historical settings. This is to deny that art is universally distributed. Although this is an alarming conclusion to those brought up on art as a kind of universal religion into which all sensitive humans enter in one form or another, it is, nevertheless, a conclusion which accords well with anthropological data (data on alien and primitive cultures).

For instance, though Aborigines regard the activity of painting on tree bark as very important, they do this as part of ritualistic procedures ingrained in their mythological practices. The finished objects are not for public exhibition, but are buried in a secret place and taken out infrequently by a select and initiated group. When taken out they form part of the religious practices of the society, and are not used in ways akin to paintings in art galleries (e.g. for the contemplation of their formal properties, or for a contemplation of man's expressive function). To take another case: Eskimo carving, which has been represented in art galleries of the world in recent years as the *Art of the Eskimo*, was not produced for visual contemplation. The carvings were done largely during the long Winter nights, and when finished

were simply discarded. Without fully entering into the Eskimo's world, and so understanding his activity, it is nonetheless clear that the object of the carving was not the creation of an object to contemplate, rather the object of the activity was *carving*. Apparently, contemporary Eskimos were surprised to find that our culture was interested in their finished objects and that there was a market for them in our art gallery set-ups. However, the fact that the carvings were worth money to the Eskimos was quite sufficient for them to turn themselves into *primitive artists*, despite the fact that in their own culture no such concept was workable.

Works of art, therefore, are identifiable as such simply because the social processes, within the form of life that art is, have fixed onto them the label 'art'. That this is the sole ground for something being art is demonstrated by the fact that to be accepted within the appropriate social area guarantees that something is art, and by the fact that the reasons for and explanations of acceptance have, over the centuries, been so diverse that acceptance cannot be anything other than arbitrary. In simpler language my point is that art, now, is nothing over and above what the bourgeoisie (high-bourgeoisie, really in the sub class of the class, the group that manufactures the ideology of the class) calls art, and that for this class to call something art is to have fixed on labels of value, which cannot be justified, though the affixing of the labels can be explained.

It is a feature of the kind of historical analysis I have been sketching in that it does not provide the grounds for a distinction between false art and real art. In other words, to say, as has been said in the history of aesthetics, that one's society's art is only the art of the upper classes, and that real art is something else, is to misunderstand the concept. Art is nothing over and above what has been socially established as art. What is called art in our society is art regardless of what future societies call art and, therefore, the supposition, at the beginning of this chapter, that our society might have got the art-list wrong assumes, wrongly, that there is

something to get right or wrong. The only mistake that can be made is one of not knowing the conventions of the society (i.e. not knowing what the society calls art). The reason for this is that the concept of art cannot be understood as an abstraction, because it is without significance divorced from an evolving set of social institutions. Art is, then, an open concept, but if we are to understand it we must say more than this because what has to be explained is on what basis the concept gets set up, and what social processes determine its development. It is necessary to investigate the social significance of the category as a whole as distinct from investigating the social significance of particular works of art.

In terms of the possibilities contained within the project of such an investigation, what has been attempted in this chapter is very slim. A detailed historical investigation along the lines proposed would be an immense task, involving a relating of the particular moments in history of the arts, and theories of the arts, to the individuals, social groups and general historical and social circumstances involved. However, to pursue this (even given the stamina and interest to do so) would be to try the patience of the intended readership beyond what is reasonable. For instance, one small part of the task would be to achieve a detailed understanding of the social, economic and various personal formulations of theories of art in Britain in the eighteenth century. However, to do this for those not interested in art at all, and to do so on the basis of wishing to confirm them in this lack of interest would come close to perversion. I doubt one would follow such an account without having a positive interest in the category to be elucidated. What has been given, then, is the barest sketch of a possible historical analysis, but this in itself is enough to indicate (a) a justifiable alternative to the establishment orthodoxy about art and (b) the startling untruths contained within the ideology of art. The possibility of an alternative perspective is the hardest thing to encourage in popular consciousness, and for this the more straightforward the treatment of the subject matter the better. The

one context where, in this book, a more detailed (socially, historically, personally) approach has been attempted concerns the final chapter. This is appropriate because the social circumstances discussed there are, because of their proximity to our own times and because of their relatedness to ordinary, social experience, easily made accessible to general, social interest. All that is required for the completion of this chapter is an underlining of the practical implications of holding the thesis about art which has been broached.

The most obvious implication, of the suggested analysis is that for those outside the 'cultural' life of the society, there is no need to look upon it as some high ideal from which, through lack of talent, intelligence or sensitivity, one is debarred, nor is there any need to feel shame-faced, apologetic or aggressive because of one's ignorance. There is no high ideal, there is only the life style of those social groups having the greatest financial resources within the society. To be of this group is, in the standard case, to find no difficulty in fitting into this life-style, regardless, that is, of one's talent, intelligence and sensitivity. For those outside this form of life, who stop to think about the central activities of the form of life, it must seem that the fact of their going on is unimportant, and in terms of their central activities this is true. People should, in the interests of people knowing how the world is constructed, know that it is a possible truth, borne out by an historical analysis, that the alleged superiority of the 'cultural' life is a deception practised by a class both upon itself and against other social classes, but once this possibility has been registered it might seem that this is the end of the matter; this is to say it might seem that little of practical significance follows from the discovery. However, there are many practical implications which only come into view when one turns away from the central activities of the practice and looks at the general proliferation of it.

For instance, our society's educational system has considerable influence on the lives of all of us. It is something

which to greater or lesser degree all members of the society are compelled to enter. In fact the educational system is the most obvious, straightforward area of coercion practised upon individuals in the society. Moreover, success or failure in this system correlates closely with the social hierarchy. Thus, those having a dominant class position in the hierarchy tend, for the most part, to succeed in the system, whereas those having more servile positions tend, comparatively, to fail, and, of course, to succeed in the system is to secure a reasonably dominant position in the hierarchy. The skills and interests, which the educational process is there to induce are heavily dependent upon the character of the 'cultural' life. For instance, the language most people naturally speak is very different from the language forms which the educational system would implant. The recommended language forms are modelled on the traditions of literary 'printable' English. There is, then, a pronounced difference between the ordinary practices of the language group and the linguistic skills required for success within the educational process. Further, within the context of being taught English at school, much time is spent studying the recognised 'high-art' literature of European and American bourgeois society, and moreover, the history of Western civilisation is very much conducted in terms of its so-called 'cultural' achievements. The ordinary language, of the people, serves perfectly well for the purposes of communication, but it is not one's ability to use this that the educational system seeks to test. The 'high-cultural' life of the society is not one of the forms of life that the mass of the people live, yet to succeed educationally considerable knowledge of it is required.

Moreover, to what extent do people, as a whole, believe in the goals of the educational process. It is clear that parents urge their children to do well at school, to compete with others and gain success, but this is not because of a deep ingrained appreciation of the 'cultural' life. The parents' desire for the child's educational success is tied to seeking social success for the child. As far as it goes this is rational

because educational success is a means to social success and financial security. However, the divergence, between the life lived and the life recommended, leads in so many cases to self-deception. Thus, without any real commitment to the 'cultural' life of the society the adult urges the child to adopt the standards of 'good English' etc. This urging is not accompanied by an unveiling of the mystification of 'good English'. In other words, the child is not told that the skills required are just some of the tricks needed to get on, and that they should be learnt as tricks but not believed in. The standards recommended are offered as established absolutes, despite the fact that the concerned parent is often unhappy with those standards himself and fails (unknowingly) to operate in accordance with them. The failure is readily apparent to those deeply entrenched in the 'cultural' life.

Of course, the various public institutions concerned with verbal communication (newspapers, radio-stations etc.) do not, even for the most part, operate with literary, 'high-cultural' language forms. Despite this the language, as recommended within education, takes as its paradigm the 'high-cultural' language. For instance, the 'high culture' radio channel, Radio 3, consistently uses announcers who operate with 'educated', 'good English' language forms. It is this language form that the schools teach. It is for this reason that the educational system disparages the language forms of Radio 1 and the popular press. The popularity of Radio 1, and the popular press, is related to the fact that, although their language forms are not those of the mass of the people, they do, nevertheless, represent a concession to the mass language and at the same time a slipping away from the educational paradigm. If the people were to reject the paradigm as a paradigm, but to accept the acquisition of the tricks, for operating in accordance with the paradigm, as useful within the present social context, the various forms of self-deception and the knots people tie themselves in could be avoided. The acquisition of knowledge about the processes at work, and a constant application of this knowledge to

one's practical reality is required, therefore, so as to avoid acting in accordance with false conceptions of oneself.

People do feel some hostility towards art, and do show some recognition of its being a confidence trick, but these are attitudes struck in response to the antics of modern art. However, this criticism is misplaced because much of modern art has been itself a send-up of the 'high-cultural' life. The publicised cases of vast sums of money being spent on objects and entertainments, which to the general public seem to have required little or no effort in their production, are common place. The general reaction to them is one of disparagment and disbelief. The general public's thin knowledge of the history of art convinces it that, although, for the most part, art is uninteresting, it has, in its production, required the exercise of skill and effort. Compared with this the production of modern art (or what is seen as being modern art) is viewed as being completely unjustifiable. In other words, the peculiar nature of modern art is rejected, by the general public, on the basis of giving grudging acceptance to the art tradition. Some point can be seen in the older art because of the work that went into it, whereas nothing can be seen in modern art because it fails to satisfy a work-ethic criterion.

However, the significance and status of the art tradition go far beyond anything that can be justified by the amount of work expended in its production, and the meaning and significance of modern art goes beyond what can be explained as the result of a weird form of laziness. It is within the modern art movement that recognition of the real, social significance of art has often been formulated. It is this which explains the peculiarity of much of the work. It has been a perception of modern art that art is just what is called art, and that to produce a work of art it is sufficient to get whatever it is, that you have produced, accepted as art. The idea that a work of art is something produced through a lonely, private struggle, at the cost of considerable personal suffering, is a Romantic idea cast off in much contemporary art practice. It is reflected that something becomes art

through a collective conspiracy (i.e. not through personal agony) and that to secure one's status as an artist is a matter of setting about stage managing the conspiracy. The object produced has been largely an irrelevant consideration, the social context in which it has appeared the all important consideration. Some artists have resorted to finding old objects, like lavatory bowls, signing their names on them and entering them for exhibition. In so far as the art context has not thrown these things out they have, over the years, become a firm part of the art category, constituting a significant trend in art history. In many cases the intention behind offering these objects has been to attack the art establishment by reducing the activities of art to transparent absurdity. If anything whatsoever can be art, then art cannot be anything over and above what is called art. If social practice designates something as art then art it is. These tendencies in contemporary art have not undermined the art category; it continues to thrive. Contemporary art is not, then, to be welcomed as an effective challenge to the life of art, but at the same time it is not to be attacked on the grounds of its not measuring up to the true standards of art. To attack movements in contemporary art, on these grounds, is to fall for the ideology of art (an ideology which does not measure up to the actual practice of art).

Falling for the ideology of art can happen in another way. It is a feature of the ideology of 'high-culture', particularly in this century, to assert that art is a universal, human category. One instance of this, already mentioned, is the way the activities of primitive people have been brought under the concept of art, despite the absence of analogous concepts in the primitive's world. In this way objects previously classified in civilised European society as museum pieces, and thereby of ethnographical interest, have been transferred to the context of the art gallery. The social significance of this has been to raise the social status of those practices which, in this way, have been brought under the concept of art. What were the curiosities of savagery become the profound

interpretations of the universe by the primitive mind. Now this commitment, within art, to the universality of art, works in another direction. Because art is thought to be found universally, so it is thought that its appeal should be universal. To be an artist is to want to say something meaningful to all men. This view is part of the ideology of art. However, it is a glaringly obvious fact about art that it is an activity for a small coterie, and does not have universal appeal. Given the ideology, there is something galling about the fact that there are other activities in the society which have considerable appeal for the general public.

A telling example of this is popular music which reaches the universal audience. Only the voice of art is held to be able to do this legitimately: that popular music does it is explained away on the basis of its not doing so legitimately. It is said it does so by encouraging unsophisticated and unintelligent people in 'cheap sensationalism' and stupidity. This is how insulting the ideology of art becomes towards the mass of the people. Despite this attack on popular 'culture', and for many different reasons, we find certain groups within the general art world attracted to aspects of this popular 'culture'. As this attraction takes on various forms of social practice, so questions are raised as to the art-status of those aspects of the popular, more universal 'culture' for which attraction is felt. In other words, as the bourgeoisie becomes interested in certain of these activities so the activities are brought under the concept of art. The social class could not allow itself to be interested in anything less than art, so what it is interested in must be art, and where the interest is in aspects of popular culture the art classification seems to coincide with the aspects of satisfying the ideology of art (i.e. being of universal appeal). This situation, however, does not remain static and so the assimilation into art encompasses a transformation of the activity. For instance, during the 60s those aspects of popular music rooted in the traditions of rock music became of real interest to a young, intellectual, middle-class public. As this happened so *art*, as an accolade,

became tenuously attached to certain forms of this music, but at the same time a transformation occurred whereby the category of 'progressive rock' came into being. As this happened so 'progressive rock' established itself as a minority interest, and it was within this category that the status of rock as an art form was entertained. This, then, was a raid into popular culture by the art world involving a carrying off of certain of its activities and changing them in the process. The borderlines between these various activities are not yet clearly drawn and many individuals straddle them all, but, despite this, it is quite obvious that the progressive rock group is more bourgeois than not (though it tends to be a young, seemingly rebellious, bourgeois group), that it is more at home with the value 'art' than other groups in the society, and that it sees its activities as forming part of universal art (on a par with the so called 'art activities of primitive people' and so called 'medieval art' and modern European art and contemporary art etc.).

This raiding of popular culture, stemming as it does from the impulse in art to be universal, has a deceptive attraction for those whose activities are ransacked. Art is a badge of success within the society, and to have it conferred on one's activities, when this is not normal, is to be inclined to bask in the value of the award, despite the fact that the total, social significance of the process of awarding, in the society, is socially discriminatory against the mass of the people. To accept the award, as high commendation, is to accept, at the same time, that one's own life style is inferior. It is also possible that if the award is taken too seriously it can suck the life out of what were previously vital activities.

I think jazz is one important area where this has happened and, in chapter four, I try to show how this has taken place. Though it is controversial to say so I think the Beatles is another case in point. Their early activities were firmly rooted in popular culture, but the more the 60s unfolded the more they became cult figures for the young, self-styled politicos of the student bourgeosie. The more they became

this the less they became the idols of the hard-core teenage audience. It was the art process that gave the members of the group the ideals of fulfilling themselves as creative musicians by entering progressive music as individuals. They could have gone on making popular music, and entertaining the people in the process, as did Elvis Presley and Cliff Richard (two people who for different reasons avoided flirting with the art process). The general life and vitality of the Beatles pheno-menon disappeared during the entanglement with 'high culture', though some of it has returned with Wings. For the cultural establishment the Beatles high moment was Sgt. Pepper (the moment when they clearly stepped over into progressive, art music) but I suspect the material that the mass of the people really like is earlier.

This attack on art, or this attempt to expose its mystifying face, is not intended to stop people putting paint on two dimensional surfaces, or making music, or dancing, or using language to create fictions. It is the organisational forms surrounding these activities which are being subject to critical examination, and what is being said is that art, as one of these organisational forms, is socially pernicious. However, there is no recommendation for an organised policy of revolt. The practical implications of the analysis are to give people the conceptual tools with which to duck the restrictive implications of the organised category of art. My belief is that to be on the side of the people (not that 'the people' constitute an homogenous entity) is to give practical help for avoiding organised policies, and one does not do this by organising everybody. The revolt against art is achieved when its conceptual bewitchment is exorcised. Organisational forms are unavoidable but so is the practice of avoiding them, and the latter requires its science as much as does the former.

Chapter Three

THE FRAUDULENT STATUS
OF ART IN MARXISM

To those who feel the given, total structure of our society works against them Marxism has an obvious potential attraction. Marxism is not one, but many things, but what, in the Western context, it is normally thought of as being is a political theory about the injurious nature of capitalist society and how it is to be overthrown. In its simplest, most general form the policy for change encompasses the organisation of those who do not own the means of production, and who, as a consequence, suffer, so as to disappropriate those who do. When this is achieved, the objective is to establish the means of production as belonging to everyone and, as a consequence, to establish a classless, non-hierarchical society. In this way the fragmentation and consequent debilitation of man, which occurs in class-based societies, is to be replaced by the full potentialities of rounded, humanised, social man.

Within Marxism there have been numerous theories (reflecting both splits within Marxism and Marxism's need to respond to changing circumstances) about how this wresting of power from the dominant, bourgeois class is to be accomplished. It has been, and is, held that a well-developed capitalist society, experiencing frequent economic depression, would be the only suitable context for making revolution. It has been, and is, held that to achieve a socialist world it is, in the first place, necessary to exert pressure on

advanced capitalist economies by fermenting Marxist revolution in the under-developed Third World. It is argued that socialism can only be constructed by a violent, revolutionary overthrow of the existing power-structure, but, in other quarters, it is argued that the Marxist society can be built through the participation of organised, Marxist, political parties in the so-called democratic processes of capitalist societies. It is argued by some that the revolution must be a spontaneous uprising by the workers coinciding with appropriate economic circumstances, whereas others think that through the organised, terrorist activities of minority, Marxist groups the general social revolution can be engineered. These views, plus many others, all relate to beliefs about the presence or absence within class-based, capitalist society of forms of resistance to any attempt to change the power-structure.

In this large debate about tactics and strategy it is a basic belief that the people must become aware of their class subordination, see it as their historical mission to change this and then set about organising themselves to change this. This en masse commitment to organising and shaping the world, so as to transform society, is seen as a long standing social commitment, which extends far beyond the revolutionary transformation and deep into man's future as a social being. The idea is that, in the newly formed society, the satisfaction of man's unpredictable and growing needs will be taken care of by a strong commitment on everyone's part to organising and running the productive life of the society. In this way it is thought that the people will be actively in control of the whole life of the society. In other words, what in present society is held to be the people controlling the society, namely the people having some determining role in the political life of the society, is, within the envisaged socialist society, viewed as a minor determining influence compared with the people controlling the whole life of the society, involving, as it does, the existence of industrial co-operatives and agricultural communes.

These notions of societies in which the people, en masse, organise and run the whole life of the society involve, at a concrete level, an organisational framework of representative committees (allied to general assemblies) which are differentiated in their functions by the level of generality required for their planning. In addition to the people's participation in the decision-making processes of the society it is assumed that there is a collective responsibility to engage in the physical processes of production, so that the whole productive life from planning to execution can be said to be a collective achievement.

These, then, are some of the responses demanded of the people, by Marxism, if they are to bring about a socialist transformation of the society. Now it might be objected, and has been, that people in advanced capitalist societies, if not people in general, would not wish to participate in these forms of organisation and the revolutionary processes they imply. This is to say, even if it was to be certain that things would in fact work out as envisaged, it is arguable that the mass of the people would not wish to be involved. Often this scepticism about the appetites of people for socialist society is founded on beliefs about human nature. However, the normal Marxist counter is to say that such beliefs are unempirical, or unscientific, being prejudices induced by the ideology of bourgeois society. Marxism accepts that in bourgeois society men, as a matter of fact, might at a superficial, conscious level, not wish to be involved in Marxist society, but this is put down to the way bourgeois society warps what is human in man. The idea is that, in bourgeois society, 'human' man goes underground whilst his false, bourgeois self appears to predominate. However, 'human' man is there all along, though suppressed, and when the social and economic conditions are ripe, then submerged man will have to assert himself, simply because this is what he really is. 'Humanised' people are those who wish to and do enter into collectivised creative, productive activity as a way of responding to and satisfying their multifarious needs.

These needs are not multifarious in the same way as they are supposed to be in capitalist society. In capitalist society people appear to want a vast range of consumer goods (e.g. hi-fi, cine cameras, electric toothbrushes, motorised lawn mowers, electric whisks etc.) and appear to want them in their latest, most fashionable form, regardless of what they possess already. Marxists see these needs as artificially induced by the profiteering impulse of capitalist society and as not being real, human needs. Despite this, real needs are still held to be multifarious because the real world, which sets man the problem of surviving, is always changing and the means people invent to deal with the real, changing world create, in their own right, new needs (e.g. machines require the organisation of machine maintenance).

'Real' people, 'human' people, as opposed to socially warped and distorted people, are said in Marxist theory to have a real need to enter into the collective production and reproduction of the material life, where both the planning and execution of this is something in which they are implicated. Marx himself did not see this commitment to the production of the material life as endless (for Marx there was the possibility of social, creative, productive activity outside the production of the material life) but since Marx, apart from the odd Marxist theorist like Marcuse, Marxism has been less utopian. The idea has been that the collectivised and democratised production of the means to life is in itself a necessary and satisfying activity. This is, of course, something which anyone reading this book can consider for himself, although to conclude that this envisaged life might be necessary but not satisfying would be explained away by Marxism as resulting from the distorting influence of bourgeois society.

However, the considerations in Marxism which give rise to the notion of 'human' people are a clumsy mixture of *a priori* philosophising (the kind of thing attacked in the first chapter) and historical insight. On the one hand, an attempt is made to distinguish between men and animals in order to

discover an essential difference and, thus, uncover what is essential to being man. This distinction is framed by Marx in terms of a distinction between creative and instinctual activity. Men are said to conceive of things in their minds before they do them, whereas animals are said simply to do things. This Marxist claim is compounded out of the legacy of Romanticism (man's distinguishing characteristic being his appetite for creativity), an artificial model of the mind at work (people do things intentionally without having to think their actions in their minds first) and a very incomplete knowledge of animals (for instance, chimpanzees can make plans which are carried out subsequently but not immediately). (J. Goodall *In the Shadow of Man.*) As Marxism locates 'human' man as creative man so it locates him in his actual historical circumstances. Thus, creative man is seen as necessary for the kind of human development there has been. What human beings have done would make no sense unless man's activities are and have been creative. Moreover, it is reflected upon that this creative development is historically inseparable from its social expression. The perceptible development is not the result of accumulative, separate, individual development, but rather the result of people acting together; a social creativity. However, as the historical analysis shows, this social creativity is not a creativity in which all equally participate. It is a feature of this historical, social creativity that it has used the social dimension as a material in its own right. For instance, the production of distinguishable economic classes has been one way that social creativity has utilised social existence so as to produce the means to life plus, for certain social groups, something in addition to this. The nature of the analysis has been then that people are essentially creative, that their creativity has always had to contend with the production of the material life, that this creativity has been a social creativity, and that it has used the social to the detriment of full, social participation in the creative essence of 'human' man. The claim on the future is one of demanding a restoration of the 'human' to all men. In

standard versions of the analysis this is possible because the
inadequate production methods, which in previous societies
have been the major factor in explaining the creative use of
the social as a negation of full social creativity, have been
overcome (as an achievement of human creativity) by the
industrial potential of capitalist society. The only thing
which stands in the way of democratised, collective creativity,
in capitalist society, is the redundant, social power structure.

Man is creative certainly, and judging by the richness of
human development and the progressive side to this develop-
ment, there is a difference in degree between the creativity of
man and that of other species. Moreover, historically speak-
ing, this creativity has been social in character and it has,
obviously enough, been exercised on the problem of produc-
ing the necessary material life. However, none of these
considerations show why collective, organised, creative, pro-
ductive activity should appear as a desirable, satisfying,
social objective. The fact that human creativity has taken
social forms and the fact that it has been necessary to
sustaining the species (and may continue to be) says nothing
about how all men can see this as their intentional fulfilment.
A necessary activity that you do not control turned into one
that you do is not to discount the possibility that you will
continue to see it as a necessary evil. That you cannot help
dealing with the world creatively is not to say that you want
to exercise your creativity in a collective. That human
creativity *has* expressed itself through collective cooperation
or, at least, through degrees of social cooperation, is not to
say that this *is* human fulfilment. The appeal, then, of the
collectively organised, creative and productive life is not
logically guaranteed by some concept of what man is, nor is it
something that the history of man demands as an empirical
truth.

So Marxism has the attraction of seeking the abolition of
the social injustices of capitalist society, but it is not just a
negation; it is a potential, whole life, in its own right, and the
attractions of this are part of the way people might consider

committing themselves to Marxism. However, to consider Marxism in this way is to concentrate on it as a theory, and it is just this that Marxism itself points to as one-sided. Marxism is not just a theory it is a practice. To say it is a practice is not to say, as is often supposed, that it demands practice, but is to say that it is in fact a collection of diverse and different practices all informed by slightly different interpretations of what Marxist theory is. Marxism, as a number of actual repercussions in the world, is a number of very well known things. In its least effective form it is the diverse, bickering organisations in advanced capitalist societies. These have some small working-class backing, but on the whole are organisations run by discontented, bourgeois intellectuals, who are committed to organising the world differently.

In the Third World Marxism is a number of things. It is terrorism, bombs, sporadic violence, guerilla warfare as well as being infiltration by the larger Communist powers, involving, as it does, things like liaisons between local capitalists and Moscow so as to expel the influence of American capital. Marxism is, also, and this is the major thing that it is, the history of the various societies referred to as Communist both by themselves and by Western, capitalist societies. The reality of Marxism in the world is, then, many sided.

To reiterate. It is the fashionable preoccupation with leftist thoughts, which has been, in different forms, a constant C20 interest of Western student groups and intellectuals, culminating during the past ten years in a very explicit identification with Marxism (this has led to a sizeable increase in the publishing of books about Marxism—another side to what has happened). The practice of this has involved marches in the major cities, street rioting, a life of small group meetings listening to guest speakers, discussing world issues and making local plans, attempts to be part of local industrial unrest and the production of different, alternative newspapers and pamphlets etc. It, Marxism, is the language in which atrocities perpetrated by some human beings upon

others in forging a socialist Vietnam or Cuba are explained
and justified. It is also the reality of their doings in the world
and the highly disciplined societies which emerge from the
ashes of the old. Marxism is the whole history of the Soviet
Union and Communist China. This includes, as everyone
knows, massive bloodshed and human suffering, as well as
the production of highly organised societies in which most of
a person's life is spent in work (whether collectivised or not).
It, Marxism, includes also the reality of the interaction
between these societies and others which, to pick out on
purpose the horrendous events, led in the Soviet case, to the
organised struggle against Nazi Germany, and, in the
Chinese case, to the active military involvement in Korea. All
of this plus much, much more constitutes the practical reality
of Marxism in the world.

I do not list these things in a pro-Western capitalistic or
pro-liberal, bourgeois and anti-Communist spirit. My point
is that these things are part of Marxism, just as the American
destruction of Vietnam and race riots in American cities are
part of capitalism and its liberal, political, public relations
system. Marxists hammer away at the gap between theory
and practice in the liberal society, but faced with the practice
of Marxism they disown it as not being in accordance with
Marxist theory. However, Marxist theory is a practice, not in
the sense that it urges people to change the world and not just
think about it, but in the sense that it is a set of living beliefs
held by those who are active in the world, and who are active
simply because they are in the world. That a theory is the key
to problems has to be measured by the serious attempts
which have been made to use it to solve them. If the results
are not in accordance with the theory then the theory cannot
be the key to the cipher. In fact, the theory may be one
element in the general, social problematic (perhaps an insolu-
ble problematic at the level of organised, social policies
which are to be adhered to by the whole society).

Of course, Marxism as theory is not one simple thing used

in different ways but a number of related practices. In the European and Western context Marxist theory exists as strenuous theorising whereas, by comparison, in the Third World Marxist theory is often little more than ready-made slogans through which exploitation and human misery can seem to be understood and can be begun to be resisted. This difference is related to a real difference between existent Marxist systems in these different areas of the world. In Eastern Europe we find very bureaucratic, highly centralised, industrial societies, which have been described by scornful Western Marxists as systems of State Capitalism. In the Marxist, Oriental, Asian context, however, we find largely agricultural societies, having strong industrial aspirations, organised along the lines of a cooperative feudalism. In neither case do we find societies coinciding with what is generally regarded to have been Marx's aspirations for socialist societies. In the Soviet context the bureaucratic, hierarchical nature of the society is at odds with Marx's conception of a grass-roots, democratised socialism. Whereas, the enormous uphill struggle being waged in China against material hardship does not square with Marx's conception of modern socialism being borne on the wings of the capitalist society's potentiality for plenty.

What I really want to suggest, here, is that European Marxism and the Marxism of the under-developed world are both at variance with the embryonic conception of the Marxist society, that they are both at variance with each other, and that they grow out of historically separate cultures. It is this last fact which determines the kind of societies which have arisen, and their theories, and the function of theories within them, rather than the body of Marxist theory itself determining the kinds of societies. To be specific, it is my view that Marxism in Europe is much more a transformation of bourgeois cultures than a repudiation of them. This is despite the language forms in which European Marxism discusses the world, which appear to dedicate Marxists to a repudiation of bourgeois society.

In the Third World the social traditions and problems as things to inherit and transform are very different. The societies, in the first place, are not bourgeois and the pressing problem is one of accelerating the process whereby such societies enter the modern world e.g. the acquisition of the technology of bourgeois society. Where, in terms of the Marxist labels worn by these different societies, one would expect unity one finds discord and this is best understood as a function of the divergent cultural settings in which the social changes have taken place. In bourgeois society the Marxist demand for change is very much in accord with the ideal aspirations of bourgeois society itself. In bourgeois society there is a split between the material life of the society and the theory of the society. The theory expounds a society which is not materially grasping and profiteering but, on the contrary, a society which eradicates material deprivation whilst at the same time advancing the people as sensitised human beings. The theories of education in bourgeois society are constructed on this basis. On the whole this is also the promise of Marxism in the European and Western context, whether in terms of Marxist groups in the West, or East European, Marxist societies.

The hypothesis I wish to suggest is that it is from amongst the intellectual ideologists of bourgeois society, from amongst, in fact, the more passive members of the bourgeoisie, that the European, Western, Marxist theory and practice emerges. It is hard to find a principal Marxist in this tradition who does not have a clear bourgeois pedigree and who has not entered into the social forms of bourgeois, intellectual life (the area of the 'high' ideals of bourgeois society). Marx, himself, is, of course, a very clear case of this. This group along with those who constitute the ideologists of bourgeois society constitute a formal, authoritarian force within this kind of society. This group insists on bourgeois society living up to its ideology, and it regards with scathing contempt the anarchic, individualism and general disregard for the historical continuity of the culture, which the commercial life of

bourgeois society produces as an unintended set of consequences. Therefore, bourgeois society creates social forms which concern themselves with the problem of justifying (theoretically) bourgeois society. The passivity of these social forms via the *status quo*, apart from reinforcing it, is not inherent in them. My suggestion is that, in the East European context, these social forms have grown up so as to predominate and have in the process ousted the system of private capital whether in the form of the individual or the private corporation. The societies of Eastern Europe are those in which, through a rigid, social hierarchy, the ideologists of the society have, in practice, the control over the economic life and cultural continuity of societies which have evolved from the potentialities of commercialism (societies in the service of private profit) into societies which, at least superficially, appear to satisfy the 'higher' ideals of bourgeois society. Even the ideal of a democratic society is retained, despite the East European societies failing to realise it just as much as Western capitalist societies, which also, in theory and in a semblance of practice are committed to it, fail in its realisation.

One of the 'high' ideals of bourgeois society is the preservation of and enrolment of people in the 'cultural' life of the society. Art, along with work, constitutes the crucial spectrum of values within this form of society. This is how the value system is realised theoretically. Work is the ethic of the society, whereby each contributes to the welfare of everyone else, and art is for the fulfilment of man beyond the realm of necessity. That the society does not work like this is irrelevant to the dominance of the theory within the society. This commitment to the 'high cultural' life is, of course, incompatible with an awareness of it as a recent, local, historical product (the substance of the preceding chapter) and manipulator of class antagonism.

Now, Marxism as a vision of a positive life (the main attraction of Marxist society once the hindrances of capitalist society have been left behind) offers the ethic of social

contributory work and fulfilment beyond this through parti-
cipation in man's creativity. It is this which is at the heart of
the Marxist theory of what it is to be human. When one
examines Marxism to find a positive content for this general
idea of participation in human creativity, one finds that it is
some idea of art which is meant. To be crude about it the best
Marxism as theory can offer people, apart from socially
useful work with a communised means of production, is art.
In other words it is to protect and preserve the life forms of
bourgeois society that the active and powerful ideologists of
East European Marxist societies have organised, at the cost
of enormous human suffering, the people. Through these
forms of organisation the contradictory, debilitating effects
on the bourgeois ideals, allowed by the system of private
capital, are avoided. Within the Western context it is virtu-
ally the same positive life that Marxist groups, when straining
theoretically to grasp the future, offer. The position is
different in China and related societies, and the reason for
this is that the forms of life of bourgeois society have not
developed there. The forms of life of bourgeois society grow
up in European society and concern other societies only in so
far as they are actively Europeanised. The forms of life,
which are to be protected, or made general, social reality, by
an organisational straightening of the contradictions in Capi-
talist society, are not sought out in all their multiplicity by
those concerned. It is the solid middle of the idealised life
forms which is sought, and not the contentious and unset-
tling edges. Thus, the social impulse, in connection with art,
is not to secure as a general, social reality the avant-garde life
of art and its constant revolutionary fervour, but to promote
as general, social experience the solid, historically well-
founded, traditions and centre of what bourgeois society
regards as art.

This hypothesis about European and Western Marxism is
vital to understanding how it is that Marxism is so muddled
and so ahistorical in its treatment of art, particularly so in its
diverse theoretical writings on the history and nature of art.

The connection here works, of course, the other way round; what Marxism says and does about art, in so far as this is a sizeable area of Marxist activity, reveals what Marxism is. It is worth tracing this through in some detail so as to expose Marxism's very assured assumption that it grasps reality very concretely as the fraud it is.

There is a well-known passage in Marx's own writings, which subsequent Marxists writing on art have constantly returned to, in which the central contradiction in Marxist aesthetics appears at the outset. The passage taken from the Introduction to Marx's *Grundrisse* is in itself pretty silly and it is surprising that so many Marxist theorists have found it so informative. What Marx wrote is as follows.

> But the difficulty is not in grasping the idea that Greek art and epos are bound up with certain forms of social development. It lies rather in understanding why they still constitute for us a source of aesthetic enjoyment and in certain respects prevail as the standard and model beyond attainment.
>
> A man cannot become a child again unless he becomes childish. But does he not enjoy the artless ways of the child, and must he not strive to reproduce its truth on a higher plane? Is not the character of every epoch revived, perfectly true to nature, in the child's nature? Why should the childhood of human society, where it had obtained its most beautiful development, not exert an eternal charm as an age that will never return? There are ill-bred children and precocious children. Many of the ancient nations belong to the latter class. The Greeks were normal children. The charm their art has for us does not conflict with the primitive character of the social order from which it had sprung. It is rather the product of the latter, and is due rather to the fact that the immature social conditions under which the art arose and under which alone it could appear can never return.

Concealed from view in this passage is the Marxist attitude to contemporary art which, with variations, runs through Marxist aesthetics. The point is that despite Marxism wishing to produce as reality the 'high' ideals of bourgeois society (e.g. socially contributory work, sensitised man through the 'higher' activities of art etc., the democratic society and man as free) it does this through a repudiation of the reality of

bourgeois society. The paraphernalia for doing this include
an attack on bourgeois self-indulgence and, through the
illumination of historical materialism, an unveiling of the
mystifying ideologies of bourgeois society. As shown, in the
last chapter, it is not possible to intelligently enter into the
life of art without entering into the value system it implies.
The art label is awarded as a meritorious badge and it
signifies the highest achievement of which man is capable. To
seethe with a cold Marxist fury at the injustices and general
banality (as they are seen) of actual bourgeois society is to be
predisposed to reject an art that caters for bourgeois self-
indulgence and bourgeois illusions. However, art, this bour-
geois life-form, is for the Marxist the 'high' ideal that the
whole efforts of a society conspire to produce. Therefore, in
contemporary art, only that which is judged to reveal society
and aid the process of revolutionary reorganisation can
match the 'high' ideal.

But, of course, the 'high' ideal which art is, is simply the set
of social practices of bourgeois society; the whole of these
practices cannot be thrown away without dispensing alto-
gether with the 'high' ideal. Moreover, the life form is rooted
in its past accretions and these do not seem to have the same
immediate, political significance *vis à vis* revolutionary prac-
tice as do the contemporary products of bourgeois 'culture'.
The life is entered into therefore, except in so far as it
pressingly and immediately conflicts with the theory for
change. To exclude certain practices on these grounds is to
provide the criterion whereby contemporary practices can
acquire the badge of merit. They acquire it in virtue of their
cutting through the layers of mystification. However, if this
standard is applied to what passes for the total history of art,
the accretions of history would have to be excluded, since
they would be judged to have been constructed out of
implicit beliefs in previous mystifying ideologies. To throw
so much away on the basis of this criterion is unthinkable in
so far as a purpose of the whole exercise is not the destruction
of art, but its proper cultivation in the service of humanity.

Therefore, a double standard is required whereby that which excludes contemporary practices as art is not applied to the history of art.

It is at this juncture that we can understand how Marx came to pose the question about the nature of Greek art. In terms of a concealed attitude about how to sift what was of value in contemporary art, Greek art could not count as valuable, but as the tradition in which Marx's whole intellectual life was embedded held Greek art to be of great value, then Marx had to find a way of explaining its enduring significance. The explanation given is silly because it purports to explain not just Karl Marx's idiosyncratic way of responding to Greek art but the general attraction, within the culture, of these Greek practices, which the modern evolutions of European civilisation had made into art. For anyone who knows anything about the way modern European 'culture' has responded to these Greek practices it is very obvious that the response is not in terms of an appreciation of the naive childhood of mankind.

So, at the outset of Marxism, we have a discrepancy between what is demanded of present art and how art's past is treated. For these two areas the value *art* is established on different bases. Marx's own explanation for the enduring value of Greek art does not become an orthodoxy, but it is symptomatic of the numerous bits of fudging that go on within Marxism to keep the art of the past intact. At no point does Marxism investigate the historical nature of art as conceptual practice. The pretensions to a historical materialist analysis of art are confined to explaining individual works of art, or forms and genres of art, as the product of historical circumstances. The origins and growth of the conceptual practice are not looked at, although on accepting the bourgeois myth about art as a universal phenomenon Marxism has provided accounts, on this basis, of the origins and history of art. Intermingled with these we find definitional attempts to say what art is. In other words the bourgeois, theoretical practice in connection with art continues

unabated in the context of European and Western Marxism.

The discrepancy, already noted in Marx's writings, reappears as a conflict in practice during the period of the Russian revolution. There is a partial recognition by certain individuals at this time that art far from being a universal, essential practice is a solidly upper-class bourgeois practice. The traditions for thinking in this way had been founded earlier by people like Belinsky, Chernyshevsky, Dobrolyubov and Tolstoy, and were taken up in the revolution by Bogdanov, Mayakovsky, Meyerhold and the Proletkult movement. Bogdanov wrote at the time, 'In the name of our future we are burning Raphael, destroying the museums and trampling on the flowers of art.' (Quoted in H. Arvon's *Marxist Esthetics* Cornell University Press, 1973.) And this indicates the iconoclastic urges of the group, though not its actual achievements. At the same time as having these extremely hostile attitudes towards what passed for art, people in these groups had positive attitudes towards certain projects. Bogdanov wished to see the creation of a proletarian literature. Mayakovsky wanted to smash bourgeois art but set up an oral art involving the recitation of poems and songs. Meyerhold was involved as director of the theatrical section of the Peoples Commissariat for Popular Culture and initiated the acting of propaganda plays, in which the actors were described as 'shock troops' in their service of the revolution. However, these people were not representative of the general and dominant attitude of the revolution towards art, and they were eventually silenced or crushed by the dominant trend; their actual significance I will return to in a moment in discussing Brecht. The official and prevailing attitude is well indicated by a variety of quotations from Lenin.

First of all Lenin attacking the Proletkult movement.

> If we do not clearly understand that a proletarian culture can be built only on the basis of a precise knowledge of the culture created by the entire evolution of humanity and by the integration of this culture, if

we do not understand that, we cannot fulfil our task. Proletarian culture is not something that suddenly surfaces without our having any idea of where it comes from, it is not the invention of the people who claim to be specialists in proletarian culture. All of that is preposterous.... *All the culture that Capitalism has left us must be carefully preserved* [my italics] and it is on this basis that Socialism must be built, otherwise it will be impossible for us to create the life of communist society. And this science, this technique and this art are in the hands and minds of specialists. (Quoted in H. Arvon's *Marxist Esthetics*)

Here, then, we have Lenin insisting on the preservation of the existing established bourgeois culture in the face of an apparently anti-art movement. Elsewhere, however, we find him clinging to the same attitude only this time in opposition to avant-garde, bourgeois modernism.

We are too great iconoclasts in painting. The beautiful must be preserved, taken as an example, as the point of departure even if it is 'old'. Why turn our backs on what is truly beautiful, abandon it as the point of departure for further development solely because it is 'old'? Why worship the new as a god compelling submission merely because it is 'new'? Nonsense! Bosh and nonsense! Here much is pure hypocrisy and of course unconscious deference to the art fashions ruling the West. We are good revolutionaries but somehow we feel obliged to prove that we are also up to the mark in modern culture! I, however, make bold to declare myself a 'barbarian'. It is beyond me to consider the products of expressionism, futurism, cubism and other 'isms' the highest manifestation of artistic genius. I do not understand them. I experience no joy from them. (V. Lenin, *On Literature and Art*)

Despite the reference to barbarism Lenin is clearly no barbarian. Like the rest of the Bolsheviks Lenin is a highly 'cultured' individual. What he is settling for is solid, conservative, bourgeois art, whereas the unsettling, constant, pseudo-revolutionary movements of modern art are cast off. However, Lenin's commitment to the revolutionary programmes means the issuing of specific directives to the contemporary art life, of which the above is only a negative

instance. More positive instances are as follows.

> ... Art belongs to the people. Its roots should be deeply implanted in the very thick of the labouring masses. It should be understood and loved by these masses ... It must stir to activity and develop the art instincts within them. Should we serve exquisite sweet cake to a small minority while the worker and peasant masses are in need of black bread? ...
> ... For art to get closer to the people and the people to art we must start by raising general educational and cultural standards. (Both from Lenin's *On Literature and Art*)

This may sound like a revolutionary programme but in fact when considered it fully accords with the ideology of art. At the ideological level art is held to be a universal activity which because it deals in fundamental human matters should concern everyone. To insist, therefore, on a process of social organisation to make this so is not to challenge the bourgeois value 'art' but rather to insist on reality conforming to the value. The doctrine of Socialist Realism which the Soviet Union adopts as the standard which Soviet art must attain insists, at the same time as insisting on art aiding the process of revolution, on it universalising the values of the society.

> Socialist Realism ... demands of the artist a truthful, historically concrete representation of reality in its revolutionary development. Moreover, he must contribute to the ideological transformation and the education of the worker in the spirit of socialism. (Quoted in Arvon's *Marxist Esthetics*)

This statement from the First Congress of Soviet Writers 1934 becomes the dominant theme for the arts in Soviet society under the 'cultural' dictatorship of Zhdanov. For instance, a statement by the 1946 Central Committee of the Communist Party of the Soviet Union illustrates the point.

> The strength of Soviet literature, which is the most advanced literature in the world, lies in the fact that it is a literature which has and can have no other interests than the interests of the people, the interests of the State. The function of Soviet literature is to aid the

State in properly educating young people, in answering their needs, in teaching the new generation to be strong. That is why everything that tends to foster an absence of ideology, apoliticalism, 'Art for Arts' sake' is foreign to Soviet literature and is harmful to the interests of the people and the Soviet State. (Quoted in Arvon's *Marxist Esthetics*)

Despite these strong sounding statements a living relationship with the art of the past is preserved in Soviet society (the heritage of 'serious' music, classical ballet, collections of paintings etc.) though such art has nothing to do with the standards of Socialist Realism, and further, and more importantly, the contemporary art which passes the standards is solidly set in the forms and genres of solid bourgeois art. This latter point is so if only because any hint of modernism or avant-gardism in art is prohibited. In fact, the charge against Soviet art as made by Western Marxists and endorsed by discontented East European Marxists (e.g. Lukacs) is that far from being revolutionary it is decadent, bourgeois art. However, those who make this attack in so far as they have some sympathy for the more modernist features of bourgeois art (i.e. modern developments in Western art) are seen from the Soviet side as supporting what is decadent in bourgeois art. They are seen, in other words, as supporting art forms which have given up any pretensions to satisfy in real practice the 'high' ideals of art ideology (i.e. the grand bourgeois theory of art). Both groups are, then, comprehended by the spectrum of bourgeois art.

This latter point is just as true of those voices in Marxism who, on the surface, appear to be anti-art. This is brought out quite clearly by Piscator and Brecht in Germany. For Piscator it was supposed to be the case that art was of no consequence. What was supposed to be of importance was to engage in political activity on improvised stages in working-class districts of Berlin. The contradictions in this project were very clearly pointed to at the time in the German Communist Party's paper *Red Flag*.

One reads in the program ... that it is not art but propaganda ... the aim is to express on the stage the proletarian and Communist idea for propagandistic and educational purposes. There is not supposed to be any 'esthetic pleasure'. But in that case the word theater should not be used: it should be called by its rightful name—propaganda. The word theater implies art, artistic creation ... Art is too sacred a thing for its name to be applied to vulgar propaganda ... What the worker needs in our day is a vigorous art ... it matters little if this art is of bourgeois origin so long as it is art. (Quoted in Arvon's *Marxist Esthetics*)

The point is that Piscator, despite his anti-art sounding theory, chose to work, to practise, in theatre. Significantly *Red Flag* in pointing to the contradiction identifies itself as orthodox Marxist in its approbation of 'culture'. Brecht's intentions are similar to Piscator's. For him the function of theatre is to do away with personal involvement on the part of the audience in the personal drama on the stage. Theatre is to be epic theatre which through the tableaux form seeks to teach. At the level of teaching the theatre is supposed to be given over to the proletariat. This latter aim (the main aim) is ironic given the subsequent fate of Brecht's plays (their continuous performance in Western bourgeois theatre). However, Brecht chooses to teach through theatre, this is the area of his Marxist practice, and questioning concerning the practical efficacy of using the theatrical form is never concretely entertained. Brecht is first and foremost a man of the theatre who would like to see it (his bourgeois context) used for ends which are, in a theatrical sense, pro-proletarian but in reality are simply 'fulfilment' of the avant-garde end of the art spectrum. That art is of great concern to Brecht is evident in his opposition to Zhdanov and the position in the Soviet Union.

Art is not capable of turning artistic ideas dreamed up in offices into *works of art* ...

... Only boots can be made to measure. Moreover, the *taste* of many people who are highly educated from the political point of

view is perverted and therefore of no importance whatsoever. (My italics and again quoted in Arvon)

In statements like these Brecht comes clean and shows art is for him a value in its own right quite apart from the proletariat (importantly the proletariat never sought out Brecht as their mentor). In this way rather than distinguishing himself from other Marxists he identifies himself as being one. For instance, if we turn to another shade of Marxism, Trotsky, we get the same phenomenon.

The products of artistic excellence must be evaluated first and foremost on the basis of their own laws, that is to say the laws of art. (Trotsky, *Literature and Revolution*)

The refusal to relinquish art as a universal, ahistorical value comes out in its clearest form in the detailed attempts within Marxist theoretical writing to formulate a theory of art. Two such theories I will briefly examine so as to bring out the unacceptable contradictions. The first is Lukacs's and the second Vasquez's in his recent book *Art and Society* (Vasquez's theory grows out of Lukacs but he does claim to transcend certain limitations as he sees them in Lukacs's theories).

Luckacs, like many other influential figures in the formation of a Marxist aesthetics (e.g. Adorno, Benjamin, Marcuse) came from a wealthy, privileged, bourgeois background. His family in Budapest was a Jewish, capitalist one, and long before his conversion to Marxism his life was given over to the arts, greatly influenced as he was by writers like Shelley, Keats, Baudelaire and Ibsen. Given that he becomes a convinced adherent to the theory of historical materialism it is obligatory upon Lukacs, in so far as his interest is in aesthetics, to give some account of the history of art. However, on examining this account it appears much more apriori and definitional than empirical and historical. The origins of art are located for Lukacs just where the bourgeois

theory of art locates them. They are connected with the development of rhythm, symmetry and decoration. We are told that the making of useful tools caused joy in the creators and that this joy contained the seeds of pleasure in the aesthetic sense. There is no anthropological substantiation of this, and no sense of the enormity of identifying pre-historical joy as embryonic aesthetic response (a notion understood by Lukacs through the bourgeois refinements of his own social situation). However, for Lukacs what he chooses to identify as decorative art is distinguished, by him, from aesthetic works (art proper!) on the grounds that the latter contains an ethical, human content, whereas the former does not. There is no attempt, here, to locate these divergent classifications socially; the investigation is quite different. The guiding principle of the investigation is what Lukacs already, before he starts, considers art to be. It is for this reason that Lukacs's account of the nature of art constantly moves through stages where it has to be distinguished from some other thing (e.g. religion, science, ethics) where the distinctions are made on the basis of handy, definitional decisions rather than observed dissimilarity of social process. Thus, art is not religion because religion is primarily 'other worldly' whereas art is primarily 'this worldly'; and art is not science because science is objective and detached, whereas art is subjective and concerned not with establishing generalisations but with showing how the particular and general fit together; and art is not ethics because ethics is concerned to instruct in what is good for the sake of producing the good, whereas art is concerned with an equal presentation of the good and bad so that they may be recognised for what they are. In none of this is contact made with reality. These are just theories and definitional games, and the life of religion, art, science, ethics never comes into view. When the level of detail is reached it is the detail of the academic and scholar (the novels, the poems, their forms and contents) and not the detail of the art life being lived.

In Lukacs what we get in the final analysis is a normative

commitment to a realist theory of art (a compound of Socialist Realism and Critical Realism) and an attempt to show that *art proper* is what is in conformity with this theory. There is some historical recognition of art not always having been a clearly separable phenomenon, that it has been entangled with religion for instance (the bourgeois theory of religious art), and that it only becomes separated clearly from the Rennaissance onwards, but this does not give rise to questions about the relationship between what exists socially and what existent systems of classification there are. It is the theory of realism which predominates and structures whatever fundamental questioning takes place, and this theory despite all the finessing that goes into its construction (reflection, speciality, type etc.) produces a sense of what art is which has been, and is, at variance with different versions of what constitute art within Marxism alone, quite apart from theories of art outside this tradition. Moreover, the theory fails to uniquely characterise art. In distinguishing between art and science Lukacs says,

> Art creates the world of men always and exclusively ... In every facet of the reflection (contrary to scientific reflection) man is present as a determinant; in art the world outside of man only occurs as a mediating element of human concerns and feelings. (G. Lukacs Speciality, as a Category of Aesthetics translated in B. Kiralyfalvi *The Aesthetics of Gyorgy Lukacs,* Princeton University Press, 1975)

It seems that for Lukacs the aim of science is to find the universal (although it works through hypotheses and approximations), whereas art is concerned to explore how the generalisations and that which is individual (something minimally interpreted and minimally understood) interconnect. All of this is vague but the point seems to be that art is concerned with what is human, and how that which is particular-human is caught up in and related to various social and material aggregations. However, to limit one's contrasts of ways of understanding the world to the neat divide between art and science (science characterised in an extremely

positivistic spirit) is artificial and certainly much too easy. What about historical materialism itself? This is to say historical materialism is not just a philosophical theory, not just a piece of ontology, it is a methodology. Would not an historical materialist analysis of a slice of the world not meet the conditions which are supposed to distinguish art from other modes of interpretation? Certainly Sartre has conducted studies which are not regarded as part of his artistic output, but which would appear to satisfy Lukacs' requirements for art (e.g. Sartre on Genet). It is true that Lukacs also sees art as being in some sense mimetic but this in itself is insufficient for 'true' art without the addition of the realist condition. As Kiralyfalvi says of Lukacs' theory,

> ... true art makes it possible for man to gain a broader and deeper consciousness of his development, putting the perspective of his life into a clearer focus so that he knows where he comes from and what direction he is going, and creating in him a 'moral readiness' to participate positively in society and life. (B. Kiralyfalvi *Aesthetics of Gyorgy Lukacs* p.144)

What then makes art important, or makes art art, is that the possibility of this sort of insight is opened up by the work. I cannot see that this condition is not met by other products, which (products) are not regarded by Lukacs, or anyone else, as art. The only possibility of some uniquely distinguishing condition left in Lukacs' analysis is that only in the mimetic form can these insights produce profound effects in human beings. Whether or not such a psychological response is what Lukacs regards as stemming from the mimetic form, it is certainly the case that he thinks works of art are important because of their capacity to produce the efficacious insight. However, as we shall see when, in a moment, we turn to this aspect of Lukacs's theories any sense of the empirical has been abandoned by him for the private convictions of the aesthete.

Not only does Lukacs' theory inadequately distinguish art from other enterprises but it also has to be stretched very

hard to apply to the acknowledged range of art forms e.g. music, dancing, pottery. Music, for example, gets in on the grounds of its being concerned with the reflection of man's inner feelings. In other words, the outer world is left untouched though the inner world is portrayed. To this extent the condition of realism is satisfied. However, the inclusion of music is half-hearted as is demonstrated by the fact that modern writers like Kafka and Beckett do not for Lukacs produce true works of art because of, in his view, their extreme subjectivism. It is difficult to see why what is a fault in literature can be the one quality which makes music, as an art form, capable of 'true' art. In fact on analysis music does have for Lukacs a lesser place. He sees it as having a lesser effect on the way a person lives his life than does literature, but this view is totally unsubstantiated in fact, and as a matter of fact is false. For evidence of this one needs only to turn to the next chapter and survey the details which are included on the lives of jazz musicians.

It is just where Lukacs' theories touch ground that it is possible to see how theoretical and how out of touch they are. Thus in writing about the effects of art, in order to justify the value of art, we get passages such as the following.

> That moving and shaking effect, that convulsion which is provided by tragedy, comedy, the novel, the good painting, the good statue and the musical creation, that purging of our passions, causes us to become better human beings than we were, to develop in us the readiness for the morally good. (Lukacs, *Art as Superstructure*, Hungary, 1955. Translated in Kiralyfalvi P. 118.)

> The effect of the art work upon man after the experience remains almost completely imperceptible, and only a whole series of similar experiences will reveal visible attitudinal, cultural, etc., changes; frequently, of course, a single art work may bring about a complete turnabout in a man's life. (Lukacs, *The Peculiarity of Aesthetics,* Berlin, 1963. Kiralyfalvi p. 120.)

It is obvious that the response to art is not being approached

as a genuine, social datum. As a matter of fact are people, who have been frequently exposed to the kind of realist art Lukacs recommends, better or morally improved people in Lukacs' understanding of that notion? If so a sizeable number of intransigent, Western bourgeoisie would satisfy the condition of having been frequently exposed to the requisite objects.

The significant fact about Lukacs is that he enters Marxism as a way of fulfilling what his commitment to the ideology of art demands of him. However, once inside the movement he seeks to retain his sense of art (an historically conditioned sense) against the unexpected adverse pull of the movement once it has built up its own unpredictable momentum. This is the function of Critical Realism which allows Lukacs to retain more of the solid centre of bourgeois art than is possible with a strict adherence to Socialist Realism plus the respect, which goes with it, for the art of the non-immediate past.

Vasquez finds Lukacs' insistence on realism 'a closed and normative aesthetic' (which it is) and proposes instead a more general theory, based on Marx's *Economic and Philosophic Manuscripts*, as constituting a more satisfactory Marxist theory of art. The basis of this theory is the view that man's essence is creativity (a view discussed earlier) and that when this creativity is exercised for itself (i.e. for the joy of creativity) and not for some necessary utilitarian end, then we have art. Thus scientific activity and purely practical activities are excluded from the range of artistic activities, whereas the use of human creativity for the mere purpose of doing, what is called, humanising the world (affirming oneself as a human being) takes one into the area of art.

> Since man is essentially a creative being, he creates works of art to feel his affirmation, his creativity, that is, his humanity. (A.S. Vasquez, *Art and Society*, New York, 1973, p.44)
>
> The similarity between art and labor thus lies in their shared relationship to the human essence; that is, they are both creative

activities by means of which man produces objects that express him, that speak for and about him. (*ibid.*, p.63)

The usefulness of a work of art is determined not only by its capacity to satisfy a determinate material need, but by its capacity to satisfy the general need that man feels to humanize everything he comes in contact with, to affirm his essence and to recognise himself in the objective world he has created. (*ibid.*, p.65)

This is a very general theory of art and the main trouble with it lies in this generality. The generality allows Vasquez to establish the connection with the *Economic and Philosophic Manuscripts* and, in terms of some pre-established sense of what art is in Vasquez's mind, the theory does not obviously conflict with anything. However, insufficient thought has been given to what the theory might include. The scant recognition that what human beings engage in beyond art are activities of practical necessity does less than justice to the richness of human activity (for instance, how are games, or sport excluded by the theory?). Moreover, certain activities within art, which do not fit Vasquez's sense of art, are rubbed out as not being in accordance with the theory and therefore rubbed out as art, when in fact it is an avant-gardist prejudice which prevents Vasquez from seeing them as fitting the theory. It is Vasquez's contention, and an avant-gardist contention, that some work (especially in the area of painting) is photographic and is concerned merely to imitate the world and, therefore, on the general theory not art. The point made is that it does not spring from man's creativity; imitation is not creation. To argue in this way shows entrenchment in narrow, empiricist theories of mind and shows, also, no recognition of recent work in art history (e.g. Gombrich's *Art and Illusion*). It is fairly obvious, if one pauses to think, that there can be no such thing in painting as straight copying from reality. One cannot observe the world, decide how it is and thereby know exactly what has to be done to the two-dimensional surface (the painting in the making) to produce a likeness (any kind of likeness, photographic or not). The problem of producing a likeness is that

of working out *what* one has to put down in two dimensions that will produce a sense of equivalence to what one has observed in the scene to be painted. This problem cannot be solved without resorting to invention. If 'creative man' is not some bogus, precious concept it must apply surely to inventive activities of this sort.

Vasquez knows, quite apart from his general theory, what he regards as art. His concept of art embraces the history of art, the period of bourgeois art covered by Lukacs' Critical Realism and modern art (recent Western, bourgeois art). Vasquez is then a Western Marxist who is prepared to lend his 'enlightened' voice to the Marxist struggle in the Western hemisphere (e.g. Cuba). The theory of art is secondary, the lived concept of art primary. This is brought out very clearly in another context where Vasquez seems to see for a moment that popular culture satisfies the general theory of art. So he allows it is art, which is surprising in so far as the culture in which it is produced does not so regard it, but as he allows this so he withdraws it. It is art, but not 'true' art, and this comes from the theorist who claims that aesthetic theory must be against normativism and the laying down of rules for creativity.

> ... under capitalist conditions the utilization of mass means of distribution results in the distribution not of great art, but of inferior, banal, routine art which corresponds to the tastes of the empty, hollow and depersonalized mass man ... (*ibid.*, p.241)

This art he calls mass art and it is identified as follows,

> These products are in the literary field, stories of the True Confessions variety, popular romantic fiction of every sort (including radio and television serials) and the great majority of crime and detective novels; in music the great majority of popular songs; and in film the great majority of commercial films. (*ibid.*, p.244)

The experiences associated with the consumption of this material and the kind of individuals (most of the people in the society) who have them are described by Vasquez in the following way.

In this type of pseudo-art feelings are stifled and the most profound passions are cheapened. Mass art is nothing but false or falsified art, a banal art or a caricature of true art, an art produced entirely to the measure of the hollow and depersonalized people to whom it addresses itself. (*ibid.*, p.244)

This then is the 'culturally enlightened' Marxist's assessment of the masses (the notion with which this book began). The view is that they need to be raised up to a form of society in which after work 'true' art is the fulfilment of the human being. Vasquez refers approvingly to Marx on this point.

Whether considering Aeschylus, Goethe, or Balzac, Marx regarded their creations as sublime expressions of the universal humanity the proletariat is called on to realize ... (*ibid.*, p.274)

I have tried to show that this is one of the main theoretical objectives of European-inspired Marxism and that this is as much a preservation as a destruction of bourgeois society. It is to achieve this that the masses are encouraged to organise, struggle, suffer, die and kill. I hope they have better things to do. Marxism is a false liberation from the moral straight-jacket of bourgeois society just as, in the next chapter, the notion that *art is jazz too* is a false liberation. Your liberation depends on having no more to do with this moral code than is necessary to keep your eye on it, like watching out for the traffic police who also appear, in their unmarked vehicles, as being at one with the masses.

Chapter Four
A WARNING OF THE CORRUPTING INFLUENCE OF ART ON POPULAR CULTURE

If art is an historically localised set of social processes and not a basic human orientation then the status of jazz as art will depend upon its being located within these social processes. Less generally, if art is a form of life sustained and lived out by various societies that either were part of or grew out of the general seventeenth century European situation, and if throughout the proliferation of and changes in this form of life stratas at the top of the social hierarchies involved (all the societies involved being hierarchical) were and are responsible for the sustaining and living out of the form of life, then the status of jazz as art will concern locatable social processes within these stratas. As jazz is the creation of coloured people, in the Southern States during the early part of this century and the latter quarter of the last, it did not begin its life within the higher social stratas, or where there were connections they were remote from these higher stratas' concern with the art continuum. If, therefore, jazz has subsequently been established as a recognised art form, or if, as seems more in keeping with the facts, inconclusive attempts have been made to establish jazz as such, then there should be locatable social traces of the attempted process of integration within the appropriate social strata. At a superficial level (the level of critical activity) these traces are easily uncovered. A consciousness of jazz as a possible art form emerges in the 1930s and is generated by the critical activities

of some European intelligentsia, localised mainly in France, Britain and Scandinavia. There is at this time a similar though distinguishable process at work in the States, i.e. orchestral jazz. Gradually this consciousness spreads to encompass American critics, jazz men and a jazz public (the latter category is by the time of this spread a non-proletarian, intellectual, ambiguously bourgeois, anti-bourgeois group—though there are fluctuations in this e.g. Bop audiences in the States and Trad audiences in Europe during the 50s).

It would not be difficult, therefore, to make plausible the argument that acceptance in the appropriate social area was a sufficient condition for jazz being a legitimate art form. In constructing this argument one could set up amusing contrasts between those committed to jazz as an art form, and, therefore, to the importance of discrimination (paradigm case being the intellectual, jazz critic and musicologist) and many of those within jazz, particularly jazz musicians, who, because not obsessed by the spectre of the art category, appal, or, at least, surprise, the jazz critic with their lack of discrimination. For example, Charlie Parker very much enjoyed the piece of music *Slow Boat to China.*

To detail this case, however, is not my primary intention. My interest is more in the fact that jazz writing (the major area where notions of jazz are made articulate) is a misinterpretation of jazz, because it seeks to relate jazz to an illusory concept of art as universal. In other words, jazz is misinterpreted because it is seen through the ideological function of the art concept, whereas jazz has entered within the boundaries of art because this seeing of it through the ideological function has been socially realised.

To begin with let me briefly indicate the way in which jazz is related to the art category as far as the most musicological or intellectual jazz critics are concerned. To this end I would like to draw attention to the writing of Hodier (A. Hodier, *Jazz Its Evolution and Essence*), Newton (F. Newton, *The Jazz Life*) and Marothy (J. Marothy, *Music and the Bourgeois. Music and the Proletarian.*

Hodier is a French intellectual and musicologist, Newton, who is apparently E. Hobsbawn in disguise, disclaims any proficiency as a musicologist, but brings to jazz writing an informed sociological sense, and Marothy is an Hungarian, orthodox Marxist and musicologist.

There are real differences between these writers concerning the particular forms of jazz they wish to most highly recommend or prescribe. Hodier believes the history of jazz has produced a classical period of jazz (for Hodier the period between 1935-45) and that jazz before and since has been inferior. Newton, on the other hand, is prepared to accept the whole of what passes in contemporary jazz circles for *real* jazz, whereas, Marothy is committed to *real* jazz (i.e. non-commercial jazz) which affirms collective experience over against bourgeois ego-centredness. In Western jazz terms (passé terms really) this position leaves Marothy a 'trad fan'; one who is very much opposed to modern developments in jazz. Despite these differences there is something which links these three writers. None of them believes that the achievements of jazz measure up to what they would consider to be the great achievements of compositional art-music. They all have great enthusiasm for jazz, and find in it values far above, as they would consider them, the values of popular, commercial music, for which they all express a disdainful loathing. Newton, for instance, saw 50s rock n' roll as music for moronic masses. In fact, compared with 'high-culture' music both Newton and Marothy find in jazz refreshing qualities. For Newton, jazz has been a democratic, anti-snobbish activity, and for Marothy jazz has been the healthy voice of the revolutionary proletariat, as opposed to the decadent voice of a moribund bourgeoisie.

Despite these concessions to the value of jazz, when it comes to the point of supposing that absolute judgements are possible all three critics see the jazz tradition as having produced nothing equal to what they regard as the great achievements of art music. Marothy believes that the kind of jazz, of which he approves, is a proletarian folk music, which

might subsequently be utilised by some great post-revolutionary composer for the ends of 'true' art. Newton, also, finds it meaningful to classify jazz by means of the folk category. For Newton, jazz is an urban, folk music, which, surprisingly has been able to maintain itself despite the commercialization of most forms of life within capitalist society. For all three critics (two of whom, Hodier and Newton, are highly esteemed in jazz circles) jazz has failed, or simply has not produced great works of art, but in a scale of value which has 'high' art-music at the top, and commercial, pop-music at the bottom (all three are committed to this scale) jazz is very high up the scale.

The positioning of jazz, in the most intellectual of critical writing, corresponds closely to the general position of jazz within the culture. Within jazz itself, from the 1940s onwards, practitioners of jazz, writers on jazz, who deal with the subject in a more anecdotal way than Hodier etc., (e.g. Nat Hentoff) and many jazz fans have been convinced that jazz *is* a new art form, created in America, mainly, though not exclusively, by negroes, and that jazzmen have an identity as artists. (Hodier etc., allow that most jazz musicians have greater technical dexterity than high-brow musicians, apart possibly from keyboard players.) However, this internal conviction does not quite equal the general institutional position of jazz. A few examples illustrate this. For instance, the bulk of BBC's jazz programmes occur on Radio 2 late at night, indicating both that they are not programmes for the mass of Radio 1 and 2's audience, and that they are not for the Radio 3 audience. Radio 3 does put out a few jazz programmes, Jazz in Britain and Jazz Record Requests but they are very much squeezed into minority slots. This is no conspiracy against jazz on the part of the BBC, but reflects their Audience Research Department's findings on the jazz public. Thus, the main bulk of people interested in 'serious music' are not very interested in jazz, and the same is true of the audience for 'light music' and pop. The jazz audience has some respect for 'serious music', and on the whole is disdainful about commercial, pop music.

The complex of attitudes surrounding jazz then, places it on the borders of art music. A situation like this is, of course, fluid, but for the last fifteen years the jazz situation has remained rather static as major social changes have gone on apace without them taking up the jazz experience. In the 50s things were different, because a young, middle-class student audience developed a short-lived 'purist' interest in jazz. At that point, jazz was entering the art category at some speed, as is evidenced by the number of serious books published about jazz at that time. However, when the student bourgeoisie of the 60s turned away from jazz to developments within pop music, jazz ceased to develop in any major social sense, though this does not reflect on changes within jazz styles during this time. Jazz is today dealt with occasionally in a serious, intellectual way by the more serious, intellectual papers, but when this happens it happens as part of a column devoted normally to progressive, pop music. In other words, it is not a standard, regular feature of the art world, but it *is* on the borders of it. The depiction of jazz as a folk music by intellectual critics is a positive indication of its position. By saying 'folk music' the critic is saying 'this is a music I stand outside of, it is not the music of my social group, but it is a music that grows authentically out of real, social experience and is, therefore, valuable'. Of course, the critic qualifies the notion of 'folk' by words like 'urban' or 'proletarian'.

My interest, as it was stated earlier, can now be presented more accurately. It is an interest in the misinterpretations of jazz which have resulted from the actual bringing of it into the fringes of art by means of various perceptions of it through the ideological function of the concept of art (i.e. art as a universal activity). One of my main complaints will be that the application of art, as a universal category, to jazz has blunted a perception of jazz as particularity.

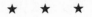

In order to explore this theme I shall begin by concentrating on the origins of jazz. Jazz, as Newton is eager to point out, is not a definable entity; it is an organic entity which has different, though related, significances at different times. A concrete point of departure on the beginnings of jazz is *A Pictorial History of Jazz* by Keepnews and Grauer Jr. On looking through the early photographs one notices changes taking place in the style of the photography. The very earliest photographs fulfil the minimal function of the photograph. The members of the bands are assembled so that they can all be seen. They carry their instruments. In many cases they wear uniform; the uniform of the band. The individuals are all assembled on the basis of them being members of a band. The individual band members look as though they have been made uncomfortable by being photographed; clearly, the photograph is not being used by them (individual by individual) for exhibitionist, self-advertisement. The photographs could almost be photographs of convicts, i.e. photographs of those who would prefer not to be photographed. Despite this, the photographs probably originate from the musicians' desire to be photographed. Photography is itself new and its application to coloured people rare. Even in 1939 photographic services for coloured people in the South were poor as is evidenced in the well known letters from Bunk Johnson to Frederic Ramsey Jr, on his inability to send Ramsey photographs of himself—'I'm pretty sure that you all know just how everything is down South with the poor colored man. The service here is really poor for colored people.'

However, a band as a whole is a larger economic possibility than an individual, and New Orleans, in the last century, afforded coloured people greater freedom than most other areas in the South. To be photographed itself conferred status. Slavery is only 30 years behind the recording of these assemblies. The band gives the negro status in his own eyes. The band is to be identified with the liberation of the negro, although this value is double-edged. The band's dress style is military and bands and music were an important part of the

liberating armies. The musicians' instruments are in all probability instruments left over from disbanded military bands. They have, then, a symbolic significance, as well as conferring status as pieces of property possessed, and as signs of personal skill or expertise. These photographs conceal a shyness, a lack of social confidence in the photographic situation, but also a preparedness to stand and be photographed because of what the band and being a member of it signified.

As jazz spreads, so as to take in wider audiences, so the style of the photographs in the Keepnews and Grauer pictorial history change. The main bulk of the examples, in the changed style, occur in the early 20s, but the style can be found several years either side of this period. This second batch of photographs testify to the musicians as socially acceptable performers of some accomplishment. The air of social acceptability is induced by a conscious photographic style. The bands are posed. It is no longer sufficient to have everyone present and so make sure that they can be seen. The content of the photograph is now carefully arranged. The whole effect is one of neatness, precision plus shades of dignity. The ensemble is chic. The fashionable style of the 20s, involving a preference for whole shapes bounded by clear contours, all slightly exaggerated by a penchant for the slender, invades the photographic presentation. The performers, then, are presented within the framework of what is fashionable, of what is of the moment. For this reason, they are presented as acceptable and desirable. They are part of *the scene*. Where the photographs are of coloured musicians they are presented as members of the chic ensemble, this is to say that the clean, conceptual contour of *band* bounds the presentation of the performers. In these photographic sessions we are not treated to off-duty poses, the performers remain part of a fashionable decor. They are surrounded by a galazy of gleaming instruments; they are the players of these instruments. The kind of playing which results is suggested by a distinction within the photographs in this style. Many

are of the performers sitting in their places on the bandstand; they come across as smooth and well-behaved. In other words they know their place. They are not slaves from Congo Square in New Orleans.

However, just as many of the photographs are posed shots of the band in action. The action is simulated. The overriding compositional structure owes nothing to realism. The emotional content of these photographs is one of rakishness and excitement. The smooth, well-behaved, coloured musicians indicate, in these photographs, the kind of music they play, or, and perhaps better, the kind of music they don't play. The more formal pose is undermined by the more anarchic one, though the anarchic pose is not genuinely anarchic; the orgiastic impulse is still well-repressed, but, now, it is showing. The musicians don't play stiff, formal music, they play music which is of 'now', which is fashionable, which repudiates the past.

The bands advertise themselves as being *Creole*, which strictly interpreted means, or meant, of Latin origins, though born in the Caribbean, and therefore, not of African origins. However, the concept of Creole in employment was a connived duplicity feeding off its literal meaning. Today the ordinary understanding of *Creole*, if not its dictionary approved meaning, is that of being light-coloured and of the Caribbean (lacking thereby a clear racial meaning). This movement in the concept came about as the result of people of various racial origins passing themselves off as Creole. The ordinary understanding of the concept gives up authoritarian literalness and yields to transparent social fact. When the Grauer/Keepnews' photographs were taken, the literal interpretation of *Creole* was not totally debased by social abuse, and it could still signify social acceptability. This is not to say that anyone really believed that the members of Kid Ory's Creole Jazz Band were Creole, it was just more acceptable when everyone engaged in the transparent fantasy that they were. In terms of fashionable acceptability it was also imperative that they should not be Creole; the important

fact was that *they should appear to be but yet be known not to be*. Here, we have an idea emerging that I shall make a lot of, namely that one enormously important life-project for the negro in the USA has been *living in order to dissemble*.

Creole band was part, therefore, of an acceptable image. In addition, the bands in the photographs appear in evening dress (there is even a band that calls itself the Tuxedo Jazz Band). We are, then, in a different world from the marching bands in their uniforms. Yet it is the same world, for it is known that many musicians appeared in both contexts. These photographs from the past, present a concrete record of a lived ambiguity. On the one hand the negro stands self-conscious but obdurate, affirming the fact of his existence, on the other hand he negates himself in dissembling European-ness. However, what really is socially acceptable and integrates is the ambiguity.

To bring out with more authority the meaning of this ambiguity it is necessary to locate the social context for which the photographs are bits of evidence.

Much research has been done and many books written about slavery in the Southern States of which *Roll Jordan Roll* is one of the latest examples. A resumé of all that evidence is not what I wish to reproduce here. Rather I wish to make concrete certain possibilities inherent in the Southern context before Reconstruction. Much of our retrospective thinking about slavery prevents us from reconstructing it as a lived situation. From assumed positions of moral superiority we vent our spleen upon the white master race (failing to note in this that there were many free coloureds who possessed slaves) and empathise with the suffering of the negro. We tend to conceptualise the situation in terms of tyranny, suffering and the unended struggle for freedom. What we avoid in this attitude is the seduction of contemplating what it was in nineteenth century America to be European in origins (but to have forsaken Europe) and to own slaves originating from Africa (a continent shrouded in European consciousness by a European concept of savagery).

In avoiding these thoughts, we avoid, as a consequence, locating what it was to be slaves responding to this situation. Clearly, there was not just one way in which this general, social situation was lived out. Gervase is right to affirm *paternalism* as a general social project, but it is not this element which, it seems to me, is the most influential, or the most relevant to understanding the early significance of jazz. It is the general possibility of *debauchery* that I wish to show was *chosen*.

In its clearest, or least concealed form we have the situation of white, male masters, overseers etc., having their way with female slaves. The typical location for this is the plantation where males, with power or authority, had a free run of the field girls regardless of existing mock, marital relations between slaves. What Sartre calls the practico-inert reinforces this propensity, for in and around New Orleans there were more coloured females than coloured males and more white males than white females (J.W. Blassingame *Black New Orleans*). The paucity of white marriageable females in the New Orleans district had led in the eighteenth century to the king of France sending out female prisoners from Salpétrière, and to the Mississippi Company organising the system known as 'casket girls', whereby girls came from France with a small chest of clothing plus a small dowry for the purpose of marriage (P. Johnson 'Good Time Town' in *New Orleans* 1718-1968 *The Past as Prelude* ed. Hodding Carter). Against this background many permanent liaisons developed between white males and coloured females, producing subsequently the social need for the category of free-coloureds as a way of responding to the offspring of such permanent relationships. These relationships were attempts in the New World context to produce substitutes for European normality, building the substitutes out of whatever material was to hand. White female scarcity and the presence of black female slaves was, obviously, a determining practico-inert, which was accommodated in different ways. The practice of using black female slaves *as slaves* for sexual

gratification was one prevalent way in which the accommo-
dation was made. But against this sketch of the crude
satisfaction of physical need, by means of utilising whatever
was to hand, we need to set other facts. For instance, the fact
that white mistresses took up with slave men (Blassingame),
or the fact that negro women were taken up with for short
durations on the basis of placage arrangements (i.e. the setting
up of a mistress in an appartment). Moreover, slaves were
allowed into masters' houses for collective celebrations,
where they dressed up in fine clothes (i.e. European style
finery), indulged in sumptuous banquetry and performed
erotic dances, like the 'carabine' and the 'pile chactas'. In
Southern Louisiana Voodoo not only sustained itself but it
drew whites into its practices, thus, in the 1850s a New
Orleans newspaper described a Voodoo ceremony as follows,

> Blacks and whites were circling around promiscuously, writhing in
> muscular contractions, panting, raving and frothing at the mouth.
> But the most degrading and infamous feature of this scene was the
> presence of a very large number of ladies, moving in the highest
> walks of society, rich and hitherto supposed respectable, that were
> caught in the dragnet.

From such facts arises an idea which goes beyond straight-
forward physical need as provoked by a scarcity of females.
The negro as negro engenders in white consciousness a desire
for sexual excess and self-indulgence. The negro symbolises
for whites the obscene and the orgiastic (if you like, the 'eros
principle'). It is partly for this reason that puritan whites
were so insistent on brow-beating blacks into a tame Christ-
ian submissiveness. Such whites saw in the slaves' drums and
their dances the possibility of the obscene orgy. On this basis,
in many areas, the drum and the dance were banned. In
Catholic areas, however, what repression there was, was
much less severe, and New Orleans itself is a clear example of
this (thus the permitted activities in Congo Square). How-
ever, in so far as whites allowed themselves to be drawn into
a celebration of the orgiastic principle, they did not do so

without various forms of concealment. I do not mean by this that their activities were clandestine (though often they were this as well), but that, for themselves in the activity, there was an attempt made to disguise an object of desire. The disguise took the form of Europeanising the object; the plaçage arrangement would be a typical example. The repressive mechanisms instilled by European culture asserted themselves in structuring the debauchery (as European values would have classified the activities). An objective was the pursuit of the orgiastic, but the pursuit did not occur in vacuo. The context prescribed other objectives, which were integral with the more straightforward objective. Thus, the orgy with blacks was a specific release; a release from repressive mechanisms in European culture. The object *was debauchery*. In more colourful language we might say the object was the rape of European ideology. For the European the orgy was a debauching. What concealed the object of desire, the Europeanised black, became the sexually exciting contradiction.

After emancipation the system of slave labour gave way to wage-labour. This change permeated all transactions, including sexual transactions. We move, therefore, from a situation in which black females are sexually utilised as slaves, to a situation in which they are utilised in various forms of prostitution. The significance of this, for New Orleans, was that at its height the Storyville district had 2,200 registered prostitutes packed into its 38 blocks. The total negro population in New Orleans at this time was around 60,000. In fact the spread of prostitution in New Orleans had threatened to engulf the whole city until Alderman Sidney Story proposed that there should be 'a certain district outside of which it would be unlawful for prostitution to be carried on'. Emancipation, therefore, altered only the form in which sexual practice took place.

The red-light district of New Orleans is, of course, an obligatory subject in describing the formation of jazz. However, the specific content of the New Orleans brothel is not

really attended to. The normal thing is to allude to the seamy origins of jazz so as to strengthen the claim that jazz is an authentic music, springing from real life situations. The New Orleans brothel is, however, an interesting phenomenon. It is not generally uniform, but there is a uniform conception emanating from the top which pervades most set-ups to a greater or lesser degree. The top is Basin Street, which is not to be confused with some seedy street in Soho. The most famous establishment on Basin Street was Mahogany Hall, run by a chubby negro woman called Madame Lulu White. Here, in its most obvious form, we have the contrast and intermingling of black and white, African and European; the contrast declaring itself in the debasement of what is European. Thus, the house, which has four stories, five grand parlours on the ground floor, 15 bedrooms on the upper floors all with private baths, is called Mahogany Hall (i.e. a fine European house but a black house). Its owner is addressed as though French, she is Madame White, but though called White she is coloured (as a matter of fact she passed herself off as Creole). She is referred to in a guide of the period (Souvenir Booklet) as follows,

> As an entertainment Miss Lulu stands foremost, having made a life-long study of music and literature. She's well-read and one that can interest anybody and make a visit to her place a continued round of pleasure.

Here, then, we see her set up as an attraction within the context of European culture. However, the magnificence of the house (in fact a rather brassy and gaudy magnificence, gross copies of so-called finest European taste), the pseudo-culture of its hosts, is all in aid of the various satisfactions of prostitution. Mahogany Hall was not a lone exception. All the top establishments were structured by these values. Thus, the Arlington is referred to in the famous Blue Book (nothing to do with Wittgenstein),

> The wonderful originality of everything that goes to fit out a mansion makes it the most attractive ever seen in this or *the old country*. Within the great walls of this mansion will be found the work of great artists from Europe and America.

Other establishments were run by Emma Johnson, known as the Parisian Queen of America (to rape the Queen of Paris) and the Countess *Willie* Piazza, where *Jelly Roll* Morton played piano (*Willie* and *Jelly Roll* both being expressions referring to the penis).

The significance of these establishments is neatly summarised by Clarence Williams talking in Hentoff's *Hear Me Talkin' to Ya*,

> And the girls would come down dressed in the finest evening gowns, *just like they were going to the opera*. Places like that were for rich people mostly white.

These brothels for the rich were not exclusively inhabited by coloured prostitutes. Many white females were also employed. This would have had a different significance from the coloured girl parading in European finery, but it obviously fitted into the overall project. It is revealing to emphasise how different was the general sexual, fantasy life of the period, as served by these establishments, compared with contemporary sexual fantasy. Sex in New Orleans, during this period, was far removed from the allure of kinky boots, Spider Woman and PVC. Even at the lower end of the New Orleans sex industry the style of sexual fantasy drew on the same sources. Thus, Louis Armstrong describes the girls standing outside their 'cribs' dressed in 'fine and beautiful negligées', in other words apparelled in erotica which worked through the associations of Europe and high class.

The top brothels were not the nests in which jazz was hatched. The music for these establishments was provided by piano players. They were known as *professors* of the piano, thus, underlining the connection with European culture. Bands were not part of the setting because they were too

obviously noisy and disruptive. There was no loud playing. The piano because of its bulk was property within property. It did not belong to the streets or the marching bands, and consequently, in the history of jazz, it had, at the beginning, a separate development. It is for this reason that early black playing of the piano expresses itself in compositional music, like rag-time, whereas in jazz proper we have to wait until Ellington for this to come about. The early, coloured piano-players were much closer to legitimate music than the instrumentalists in the street marching bands and dance bands, although this division was not absolute, as is evidenced by the different status of various instruments in the bands (e.g. the violin and clarinet were more closely associated with legitimate music than the other instruments). The piano comes into jazz, as jazz leaves the streets and enters the interiors. This movement is not simply the jazz band becoming sedentary, it is the influence of the jazz idiom and integral and attendant social attitudes upon the piano-players. One of the clearest expressions of this intersection is in the development of boogie woogie, where the left hand takes up the function of the guitars rhythmic chording while the right hand fulfils the piano tradition of filling in so as to provide a total event.

In Countess Willie Piazza's place Jelly Roll Morton performs as professor of the piano, but the echoes of jazz pervade the sweet volume-level of the music. The black/white contrast is written into not only the name of Mahogany Hall, but into the musical atmosphere as well. This contrast is the meaning of the social experience that it was. An isolated, but important event which emphasises this meaning was the closure by the federal governments of the 'Storyville' district during World War I. This came about when four sailors were killed in the district. At the point of America showing solidarity with a particular European cause, it became necessary for the authorities to excise that which was anathema to it.

The contrast, I have been examining, is not confined to the

sordid fringes of New Orleans society, although, in New Orleans, prostitution was in fact more than a fringe activity. The contrast is ubiquitous throughout New Orleans as a good time town.

Until the 1850s New Orleans was the musical capital of America (H.A. Krun 'The Music of New Orleans' in Hodding Carter's (ed) *The Past as Prelude*), but this is misleading unless we concentrate on dancing and ballrooms. It is this which is the vastly popular activity. New Orleans did have an opera house, but it was not always popular, and probably would not have survived apart from the support of the ballrooms, in the form of their providing alternative sources of income for musicians. However, it was important that there was an opera house, for compared with the ballrooms, it allowed social consciousness to live out the contrasts I have been arguing for. It was more important though, that there were the ballrooms.

The importance of the ballroom reveals itself when we know the kind of social experience it permitted and encouraged. Masked balls, in which social divisions of birth and colour were played down, were very popular. Prior to 1805 there was mixed dancing where white men (fathers and sons) would come together to revel and dance with free-coloureds and slaves both men and women. From 1805 the Quadroon Ball was introduced by an Auguste Tersier, whereby, on Wednesdays and Saturdays, dances were held exclusively for white men and free-coloured women only (the category of free-coloured women being easily enlargeable by any coloured women a white man fancied setting up as such). The real significance of this move was the removal of the coloured male from the context in which the white male exhibited, through the mask of social conventions, his sexual desires. The Quadroon Ball proved an instant success. As a Louise Tastio wrote at the time,

> Every clerk and scriviner who can make up a few dollars, hurries to these unhallowed sanctuaries, and launches unreservedly into every

species of sensual indulgence.... Nor is it unusual to see members of
the legislature mingling freely with these motley groups. (Quoted in
Krun article)

It is in these settings, and similar ones, that towards the
end of the century the original jazz bands performed,
alternating between this role and that of marching bands.
The idea that jazz as dance music was an early twentieth
century invention of Tin Pan Alley, which is Francis
Newton's claim, seems to me quite wrong. It was at the
beginning a dance music, and more than this a dance music
within a commercial setting. The ballrooms were in competi-
tion with each other and emerging out of this commercial
rivalry we get the tradition of the 'cuttin'' contest, which was
still apparent, though transformed greatly, at Mintons, when
Monk, Parker and Gillespie set about inventing a jazz that no
one else will be able to live with.

I have now said something about the social context in
which a certain social project was lived out. A set of
simplifying contrasts help to clarify my meaning. Being
white, as encapsulated in New Orleans social experience, was
bringing blackness into whiteness, and thereby obtaining
some release from being white, but at the same time *not being
black* and remaining white. The project was contradictory, it
was to be white, but not be white and to be black but not be
black (all of this from the standpoint of those who were
white), it was to *bring blackness into whiteness as a whiteness*
but at the same time *that which entered as a whiteness had to
be a blackness*. We might say all of this constitutes the
American setting or, at least the white American setting. The
European grip on America is not strong but for a while a
rather garbled version of European style is an inspiration,
especially with certain powerful social classes. The American
experience is the way in which this grip is gradually dismant-
led. Europe is the fantasy, and in the fantasy Europe is
'debased' and this is central to being American. This can be
represented in economic terms for American capitalism is the

powerhouse, which is the ultimately effective destroyer of the pervasiveness of European culture. But all of this is, at present, from the standpoint of white Americans. What is needed is an account of this complex from the other side. To approach this I shall return to an adjunct of my main enterprise, that adjunct being the formation of jazz.

In schematic form to be black is to be committed to a double dissembling. First there is *the being black*, but the having *to appear as white* though revealing blackness through the white pose. This is the demand white society makes on blacks. The demand, however, is twofold. It is the demand that what *is* black *makes itself white* through dutiful behaviour (dutiful, white labouring-classes) but that it remains black, i.e. slave, third class citizen, non-equal. This demand is the exploitation of the blacks' productive capacity. Secondly, there is the more seductive demand (seductive to those demanding) that the excitement and release of blackness be offered through a disguise of whiteness. The black then *dissembles whiteness to have his blackness exploited*, but this is the external demand, and what we need to specify is how meeting the demand is interiorised. It is interiorised *by dissembling the dissembling*. This is to say the negro makes bland naivety at imitation indistinguishable, at an interpersonal level, from cynical mockery. If there is an awareness of this duplicity there is a tendency for whites to connive at it, because the desired object *blackness* is not simply shades of Africa and savagery, but the send up of uptight whiteness (this it seems to me is a contagious cultural influence).

If all this sounds like an analysis of the Black and White Minstrel Show, it should be remembered that Minstrelsy was very popular at this time, and it was a context in which all these contrasts and ambiguities were played out in stark caricatures. For instance, the walk around at the conclusion of a Minstrel show involved the Cakewalk (see 1899 photo in *Black New Orleans*), which was socially acknowledged as an impudent imitation of European, good posture and correct

walking (of course we all move like negroes now, you know, 'float like a butterfly sting like a bee'). The blacked up whites also celebrated the negroes' phallic potential. Thus, they sang of being able to bend trees until they had humps like camels, or of their being able to pull a steamboat out of the river with their fishing rods, or of how they could sail down the Mississippi on the backs of alligators which turned into sea serpents, which they then rode for miles underwater without breathing. Apparently when one of these minstrels found his entrance to a river blocked by a giant catfish he simply sailed his boat right at its mouth and turned it inside out (how could any woman resist?) (*Blacking Up*, R.C. Toll). For the negro then, the dissembling whitness was made in the form of dissembling the dissembling. To be negro was to be two-faced. The formation of jazz is one important area in which we see this happening.

In the work songs and early blues we are dealing with material which, as all experts accept, was designed to be ambiguous. There is the meaning of the song which is acceptable to the European overseer, and there is the sardonic, send-up meaning (sometimes clandestine message) which delights the singers. An attitude is being bred here. It is that of not meaning what you say, and *living to say what you don't mean*, while at the same time implying what you mean and *living to imply meaning*. Success as a negro amongst negroes is measured by your success at dissembling. The Blues makes light of suffering so as to underline it. In the early jazz the perfectly acceptable European melody appears to be present, and to be holding the piece together, but something else is intertwined within it, which is something saying something else. Here, we are dealing with what is now called 'improvisation', but in the early days of jazz it was known to everybody as *'faking'*. (Perhaps we have run full circle when we get to Coleman Hawkins wondering whether or not Ornette Coleman might be faking and thus might not be for real.)

At one level the European hears ingenuous attempts at

imitation, but as an explanation this is inadequate; there had been many earlier, negro bands (many of them military) who could play the music straight. Improvisation is a feature of West African music, but we would be woodenly empiricist if we left it at that, i.e. one element that went into some mysterious brew, brain-computer scramble etc. Improvisation is, in terms of the background, a congealed possibility, but in the New World context it is a chosen possibility, as a way, in the first instance, of dealing with the problematical contingencies of the work gang e.g. the passing of the message. The improvisatory problem, in the context, is one of working some new provocative element into a settled, acceptable format without disturbing the format's acceptability. The skill is one of *working it in.* This is clearly brought out by a J.M. Mckin writing in 1862 and quoted in Marshal Sterns' *The Story of Jazz*:

> I asked one of these blacks—one of the most intelligent of them ... where they got these songs. 'Day make 'em, sah!' 'How do they make them?' After a pause, evidently casting about for an explanation, he said 'I'll tell you, it's dis way. My master call me up, and order me a short peck of corn and a hundred lash. My friends see it, and is sorry for me. When dey come to de praise-meeting dat night dey sing about it. Some's very good singers and know how; and dey *work it in* ... work it in, you know, till dey get it right; and dat's de way.

In the early jazz the improvisation feeds off the melody and its harmony. In this way the acceptable statement is transformed. European standards of strict tempo are evaded, with the accents coming off the beat and the stressing of weak beats. This produces a music which is shifty and evasive rather than open and straightforward. I often feel that musicians brought up on classical music who, when trying to play jazz, meet insuperable difficulties do so because their training has been one of always trying, honestly and openly, to be in the right place at the right time. In a lot of jazz you have got to let things slip a bit only to redeem yourself at the

last moment, like the clown on the tightrope. The important thing is, according to European standards, to be in the wrong place, but to know how to get back in line (note how Charlie Parker is revered for his extraordinary capacity for doing just that). Here is the source of the sense of release that the early jazz offers; i.e. a release from an on the go, goal-orientated, rule-bound, repressive consciousness. In this connection the attractions of primitive Africa and African rhythm seem more a cultural image surrounding the music than a feature of its intentional content. We have, in the music, the standards and the slipping from them, and for the musician, I am suggesting, the important thing is the living out of the ambiguity.

This is how the blacks come into the American experience, from the other end, so to speak. The two-faced negro is the American negro. He is deeply embedded in the history. The image of the negro passively accepting Southern paternalism is an obvious historical fallacy (see *Negro in American History*, Director of Schools, New York City). Plantation owners and their families were often the prey of their slaves. The history of the negro in America is full of minor rebellions, which are inevitably followed by savage repression. But more than this, the negro is constantly working a fast one. He runs away, he appears to work but only does so at half pace, he feigns illness when he is healthy. We might note that all of these dodges are commonplaces in the contemporary life of cynical sections of the Western proletariat. The object of the black life is to 'two time' the white, boss race, or, it is one of the objects, and it is an object which transforms the way in which all other objects are sought and the way the seeking of them is lived. This two-faced quality is apparent just where the negro is often thought to be at his most straightforward and sincere, i.e. in religious devotions. Religious activity when permitted was for the negro the acceptable context in which to be unacceptable: the context in which to symbolically throw off social and ideological tyranny. Religious activity in America provided similar

opportunities for migrating European proletarians (Shakers, etc.). The possibility of sincere, ingenuous response created the hesitation in white consciousness, which allowed black religious devotions to grow unimpeded. This possibility is more than hinted at by the European traveller Fredrika Bremer, when she visited a Methodist church attended by slaves (Blassingame).

> The *children* of Africa may yet give us a form of divine worship in which invocation, supplication, and songs of praise may respond to the inner life of the fervent soul!

Moreover, the mocking, deadpan tone of the negro is evident in his religious activities. The mode of expression is not just the song of deliverence. Compare the pomposity of the following European lyric, with the sharp send-up of the negro version which follows it.

> Praise to the living God
> All praised be his name
> Who was, and is, and is to be
> For aye thro' the same
> The one Eternal God.
> Ere aught that now appears
> The first, the last beyond all thoughts
> His timeless years.

> God is a God
> God don't never change
> God is a God
> And he always will be God.

Of course, blacks could not enter into these white practices without cost. Just as black was affecting white, so white was affecting black. Whites were becoming black and blacks were becoming white. Christianity as a repressive ideology takes its toll. Baldwin's novel *Go Tell it on the Mountain* is a graphic illustration of this. Despite this, religious practice was for the negro a further opportunity for saying one thing but meaning another.

Just as the serious intention behind the whites' religion is evaded and sent up, so is the serious intent behind the white man's band. This is underlined by the military associations which the band had for the negro. The negro gains, in American history, a concept of freedom through military experience. In the colonial war some measure of prestige accrued to the negro as a result of those instances where it became necessary to employ him for military ends. In the civil war, a successful outcome for the Northern armies promises the abolition of slavery. This prospect is concretely responded to by an estimated number of 186,000 negroes joining the Northern forces, many of them defectors from the South. About a sixth of this number failed to survive the conflict. The North and the policy of abolition come together as the war becomes protracted and difficult. It is realised that the economic strength of the South is heavily dependent on unwilling slave labour. Therefore, an alliance with the emancipationist cause, on the part of the North, is a tactic which undermines the security of the Southern economy. The invitation from the North to the Southern slave is to defect in return for which the North promises emancipation (i.e. wage labour). The promise of emancipation is carried into the South by the victorious Northern army, much of which is composed of negroes. The victory is paraded and celebrated by means of the exhibitionism of the military band. However, the promise is a false one, for though slavery is abolished the material circumstances of the negroes' life remain much as before. The concept of the band is thus adopted by the negro as a way of saying what you don't mean. New Orleans had a history of white marching bands; the black marching bands therefore develop their parody of the white band.

There is one other very important predisposing factor for the way in which the black response to white society shapes itself in the living project of making jazz, and that is the fact of the frequent making of music by black males for the social intercourse of white males and coloured females. Many

books covering this period refer to black masculinity or
'manliness' being under threat in the Southern social situa-
tion. I'm not sure I really understand what this means, but,
certainly, the subsidiary role of entertainer, at these func-
tions, would explain the production of a concealed, though
ribald irony. For reasons stated this ribald element was not
unwelcome to the audience. Marothy provides a concrete
illustration of this in discussing glissandi or slurs in jazz.

> The glissando effects (whose actual significance is naturally not
> restricted to the comic) produced a unanimously comic impact on
> the bourgeois audience, because here an excessive sentimental
> expressivity and also its reversal were clearly to be observed.

Marothy, here, helps to underline the double-edged quality
of this music.

The theme of jazz musicians passing ironic musical com-
ment on the prelude to miscegenation is one that outlives the
New Orleans period. The Cotton Club where Ellington was
resident for all those years was based on the appeal of sexual
fantasy surrounding the coupling of blacks and whites.
Marshal Sterne in *The Story of Jazz* describes a typical
tableau.

> The floor shows at the Cotton Club, which admitted only gangsters,
> whites and negro celebrities, were an incredible mishmash of talent
> and nonsense which might well fascinate both sociologists and
> psychiatrists. I recall one where a light-skinned and magnificently
> muscled negro burst through a papier maché jungle onto the dance
> floor, clad in an aviator's helmet, goggles and shorts. He had
> obviously been 'forced down in darkest Africa', and in the centre of
> the floor he came upon a 'white' goddess clad in long golden tresses
> and being worshipped by a circle of cringing 'blacks'. Producing a
> bull whip from heaven knows where, the aviator rescued the blonde
> and they did an erotic dance. In the background, Bubber Miley,
> Tricky Sam Nanton, and other members of the Ellington band
> growled, wheezed, and snorted obscenely.

I estimate I have said enough to indicate what I take to be

the meaning of the formation and early proliferation of jazz in and around New Orleans. What I have tried to do is to sketch in the *lived making* and early spreading of this process. As a methodology this is a departure from the standard empiricist enquiry, which breaks down the *fait accompli* into easily managed elements (e.g. polyphony, polyrhythm, blue notes, improvisation etc.) and then seeks to find something comparable in the pre-jazz background (e.g. African pentatonic scales, Anglo-Saxon hymns, etc.). The empiricist enquiry gives fusion (i.e. natural process) pre-eminence over human project. At the same time as recommending a certain methodology, one which insists on rendering the activity intelligible as something intentional, it is necessary to point out that the activity rendered is not simply transparent intentionality. The activity, because it is real, contains all sorts of possibilities for new departures which were undreamt of in its original formation. What new departures there are though, have still to be rendered as lived activity.

I am now in a position to declare my main point with more obvious intelligibility. To begin an exploration of jazz with the presupposition that it is art, or is a music of 'high aesthetic value' (the latter claim is typical of books on jazz, reflecting, I suspect, the actual borderline status of jazz) where one is committed to these values, prevents one from feeling jazz as hostile to oneself and a rejection of oneself, but, at the same time, feeling it as an undermining of oneself by being a release from oneself. Prevented from finding this interaction of objectives one fails to locate the white presence in early jazz. Early jazz is as much made out of white, commercial demands of black musicianship as it is made out of black musicianship itself. Jazz is a commercial music from the beginnings. It is not as though the commercialisation of jazz only gets under way with the Original Dixieland Jazz Band and beyond. It is true that as the record and radio industries develop so certain concepts of jazz are spread by the abstract hand of capitalism, and that prior to this

commercialisation is under more concrete control. This isn't
the difference between folk and commercial music, any more
than the difference between the New Orlean's underworld
and Capone's Chicago is the difference between folk culture
and muscular capitalism. Being a musician in New Orleans
was to have a trade, like cigar making or carpentry. If not
full-time it was a supplement to one's income. Even the
playing at funerals, for the various lodges and secret societ-
ies, was on a commercial basis, and the music only became
'hot' (as they used to say of early jazz) after the band had
been paid and they were on their way back to town.

 To think of jazz as art is to think of it as an ally. From this
standpoint one abstracts from the particularity of the lived
process those elements which are compatible with the stand-
point. Jazz as a lived process, having a predominant meaning
thereby slips from view. As this happens a fantasy jazz
emerges firmly within the grip of the aesthetics of Romantic-
ism. Jazz is thereby seen as a clear, unambiguous, authentic
expression of black feeling. Sometimes the straightforward
expression of an African vitality and at other times the ex-
pression of suffering and the making of bitter ironic
comment. There are the feelings, there is the vehicle and jazz
is the communication of these feelings by means of the
vehicle. In this way the jazzman is highlighted as the artist.
This is to say that as long as his problem can be conceived
simply as making the vehicle communicate his feelings, then
his status as an artist is assured, even if it is a status as a lesser
artist (folk artist). As soon as outside, commercial pressures
are thought to intrude, i.e. when jazz is seen as being
marketed and when whites are seen as playing a version of it
because it is marketable (this is the conception of the ensuing
process that the theory gives us) then the status of jazz as art
becomes a complex problem: the problem of discrimination.
While lost in the problem of discrimination the meaning of
the ensuing process is not explored. The ideology sets up the
meaning *a priori*. Thus, the meaning becomes, who was and
who was not able to maintain themselves as authentic

expressing artists against the tide of commercialism. The history is read for this interpretation and nothing more. Once this is done all that is left is to detail what has been accepted. Detailing involves the gathering of anecdotes and the analysis of the evolving musical techniques. Typically, also, we get the lament that the great jazz artists have not been rewarded for their genius, although if in the money the jazzman is normally thought of as being of questionable status e.g. Benny Goodman and Miles Davies (a similar process is to be found in pop-rock as a letter to the *Sunday Times* 12 Oct 1975 pointed out of that newspaper's colour supplement pop-rock feature).

A better understanding of the spreading of the jazz experience (especially concerning 20s and early 30s) comes from those who living with its spread took up a position of hostility towards it. Neil Leonard's book *Jazz and the White Americans* catalogues some of the opposition. In 1901 the American Federation of Musicians condemned ragtime, and recommended that its members refrain from playing it. In 1911 people found doing the Turkey Trot were taken to court and subsequently lost their jobs. By 1922 there was a play on Broadway by Hartly Manners called *National Anthem,* whose theme was the moral debasement and degeneracy brought about by jazz. The New York Times of the period was against it — 'With music of the old style even the most moving, the listener was seldom upset from his dignified posture.'

J.P. Sousa objected on the grounds that jazz employed primitive rhythms which excited the basic human instincts. This attitude was expressed in greater detail by a Dr Eliot Rawlings, quoted by Leonard.

> Jazz music causes drunkeness by sending a continuous whirl of impressionable stimulations to the brain, producing thoughts and imaginations which overpower the will. Reason and reflection are lost and the action of the persons are directed by the stronger animal passions.

The Catholic Telegraph of Cincinnati continues the theme,

> ... the music is sensuous, the embracing of partners is absolutely indecent, and the motions ... they are such that as may not be described in a family newspaper. Suffice it to say that there are certain houses appropriate for such dances but those houses have been closed by law.

A Miss Alice Burrows publishing an article entitled 'Our Jazz Spotted Middle West' in the *Ladies Home Journal* for 1927 writes,

> The nature of the music and the crowd psychology working together bring to many individuals an unwholesome excitement. Boy and girl couples leave the hall in a state of dangerous disturbance. Any worker who has gone into the night to gather the facts of activities outside the dance hall is appalled, first of all perhaps, by the blatant disregard of even the elementary rules of civilization. We must expect a few casualties in social intercourse, but the modern dance is producing little short of holocaust. The statistics of illegitimacy in this country show a great increase in recent years.

According to the Rev. Phillip Yarrow the Illinois Vigilance Association had discovered that for the year 1921-2 jazz had caused the 'downfall' of 1,000 girls in Chicago alone. The anti-movement was not without its sense of humour, as is evidenced by articles bearing titles like 'Does Jazz but the Sin in Syncopation'.

Milton Mezzrow, the jazz clarinettist, recalls the official establishment attitude towards jazz in the 20s: 'Our music was called "nigger music" and "whore house music" and "nice" people turned up their noses at it.'

Religious dignitaries saw the wider implications. A.W. Bevan, a minister in Rochester, New York is quoted as saying, 'It has gotten beyond the dance and the music and is now an attitude toward life in general. We are afflicted with a moral and spiritual anemia.'

Dr. J.R. Streton, a baptist clergyman in New York said,

I have no patience with this modern jazz-tendency, whether it be in music, science, social life or religion. It is part of the lawless spirit which is being manifested in many departments of life, endangering our civilization in its general revolt against authority and established order.

These outbursts against jazz were not confined to angry letters written to newspapers, but had practical implications as well. It needs to be remembered that these attitudes were linked to the attitudes behind 'prohibition'. In 1921 the General Federation of Women's Clubs with a membership of 2,000,000 voted to 'annihilate' the new music. At the time of prohibition there was legislation against jazz. The New York legislature passed the Cotillo Bill which empowered the Commissioner of Licences of New York City to regulate jazz and dancing. He banned both on Broadway after midnight. By 1929, 60 communities including Cleveland, Detroit, Kansas City, Omaha and Philadelphia had regulations prohibiting jazz in public dance halls.

The opposition to jazz has to be measured against the spread of jazz, but by itself it underlines the social meaning of jazz. Adherents of jazz, who view it as participating in eternal aesthetic verities, dismiss this opposition as reactionary and blinkered, not seeing that this opposition is a particular response to jazz as something concrete. In contrast, the adherents response is abstract. The opposition expresses itself naively, but many of its positions have been presented with more sophistication (if this is thought a virtue) as does, for instance, Adorno (T. Adorno, *Prisms*, 'Perennial Fashion'). I am very much against Adorno's condemnation of jazz but I am in agreement with much of his analysis. It is a strange experience to agree with so much that is said but to be so fundamentally opposed to the whole. Consider, therefore, how Adorno's views present a more sophisticated opposition to jazz, whilst paralleling many features of my own analysis,

However little doubt there can be regarding the African elements in Jazz, it is no less certain that everything unruly in it was from the very beginning integrated into a strict scheme, that its rebellious gestures are accompanied by the tendency to blind obeisance, much like the sado-masochistic type described by analytic psychology, the person who chafes against the father-figure while secretly admiring him, who seeks to emulate him and in turn drives enjoyment from the subordination he overtly detests.... It is not as though scurrilous businessmen have corrupted the voice of nature by attacking it from without; jazz takes care of this all by itself.

He goes on,

Among the symptoms of the disintegration of culture and education, not the least is the fact that the distinction between autonomous 'high' and commercial 'light' art, however questionable it may be, is neither critically reflected nor even noticed anymore. And now that certain culturally defeatist intellectuals have pitted the latter against the former, the philistine champions of the culture industry can even take pride in the conviction that they are marching in the vanguard of the Zeitgeist.... The legitimate discontent with culture provides a pretext but not the slightest justification for the glorification of a highly rationalized section of mass production, one which debases and betrays culture without at all transcending it, as the dawn of a new world sensibility, or for confusing it with Cubism, Eliot's poetry and Joyce's prose.... Anyone who allows the growing respectability of mass culture to seduce him into equating a popular song with modern art because of a few false notes squeaked by a clarinet, anyone who mistakes a triad studded with 'dirty notes' for atonality, has already capitulated to barbarism.

Here, European Marxism declares itself as the defender of the old culture. This is an attitude we find in Marx and an attitude deeply entrenched in the Soviet Union. There is a clinging to the 'higher' life of the bourgeoisie as it evolved during the period of settled bourgeois dominance. This 'higher' life is in opposition to the real material life of the bourgeoisie. The real material life produces the possibility of proletarian life-styles which are antagonistic to, and unassimilable into the 'higher' life. Significantly Marxism seeks the disappearance of the proletariat, and where Marxism comes to terms with jazz it does so by denying the Adorno charge of

barbarism; it sees jazz, rather, as art. This kind of identification is one Tom Wolfe goes in for. Wolfe is a heightened exaggeration of the Adorno opponent, and one I doubt Adorno imagined possible when writing 'Perennial Fashion'.

> ... Nobody will even take a look at our incredible new national pastimes, things like stock car racing, drag racing, demolition derbies, sports that attract five to ten million more spectators than football, baseball and basket ball each year. Part of it is an inbuilt class bias. The educated classes in this country, as in every country, the people who grow to control visual and printed communication media, are all plugged into what is, when one gets down to it, an ancient, aristocratic aesthetic. Stock car racing, custom cars, and, for that matter, the jerk, the money, rock music ... still seem beneath serious consideration, still the preserve of ratty people with ratty hair and dermatitis and corroded thoracic boxes and so forth. Yet all these rancid people are creating new styles all the time and changing the life of the whole country in ways that nobody ever seems to bother to record much less analyse. (T. Wolfe, *Kandy Koloured Tangerine Flake Streamline Baby*, Introduction)

Continuing his attack Adorno equates the specialist jazz fan with logical positivist,

> There is a striking similarity between this type of jazz enthusiast and any of the young disciples of logical positivism, who throw off philosophical culture with the same zeal as jazz fans dispense with the tradition of serious music.

It would be interesting to know how many logical positivists were specialist jazz fans. I suspect quite a few.

Trying to account for the mass basis of jazz, Adorno puts forward an image that coincides with one I offered earlier, namely the stumbling clown.

> Jazz must possess a 'mass basis', the technique must link up with a moment in the subject—one which, of course, in him points back to the social structure and to typical conflicts between ego and society. What first comes to mind, in quest for that moment, is the eccentric

clown or parallels with the early film comics. Individual weakness is proclaimed and revoked in the same breath, stumbling is confirmed as a higher kind of skill. In the process of integrating the asocial jazz converges with the equally standardised schemas of the detective novel and its offshoots, which regularly distort or unmask the world so that asociality and crime become the everyday norm, but which at the same time charm away the seductive and ominous challenge through the inevitable triumph of order.

With the rise of the Nazi movement in Europe, Adorno took refuge in America. Judging from 'Perennial Fashion' Adorno appears to have integrated badly into American society. He writes,

> ... To comprehend the mass basis of jazz one must take full account of the taboo on artistic expression in America, a taboo which continues unabated despite the official art industry, and which even affects the expressive impulses of children;... Although the artist is partially tolerated, partially integrated into the sphere of consumption as an 'entertainer', a functionary—like the better-paid waiter subject to the demands of 'service'—the stereotype of the artist remains the introvert, the egocentric idiot, frequently the homosexual ... A child who prefers to listen to serious music or practice the piano rather than watch a baseball game or television will have to suffer as a 'sissy' in his class or in other groups to which he belongs and which embody more authority than parents or teacher.

Here we have Adorno faced with the American experience one aspect of the making of which I have been trying to detail. His final verdict on jazz is that its subject expresses, 'I am nothing, I am filth, no matter what they do to me it serves me right', and that, 'Jazz is the false liquidation of art.'

These different forms of opposition bring out very clearly the view that jazz as a mass phenomenon was not an adjunct of art and 'high-culture', but a repudiation of it. This view I agree with. The opposition was in response to the spread of jazz, it was a response to the real threat posed by the jazz experience. This threat kept re-emerging in jazz, or in close offshoots of jazz, up until the closure of the bop/trad era.

The different forms of threat were accompanied by different forms of opposition. From the end of the bop/trad era similar repudiations and threats emerged from cultural forms which sprang from the same roots as jazz but which constituted a distinct and separate branch e.g. Rock n' Roll. These developments carried with them their own forms of opposition, which have been depressingly similar to the forms of opposition I have just been exploring. On this evidence alone Adorno's concept of static revolution seems appropriate.

★ ★ ★

The reoccuring fact of jazz as threat, as repudiation, in the history of jazz, has to be set alongside the fact of jazz falling within the confines of art. The perception of jazz as art is not something separate from the history of jazz; it is a very important part of its history. In other words, the misinterpretations of jazz history have been part of jazz history and they have entered deeply into jazz in its entirety. To explore this theme it is necessary to explain the history of jazz as it follows on from the early period. Clearly, this is a vaster problem than that posed by the early history of jazz. In response to this larger problem I shall offer no more than a detailed sketch, which will try to account for the phenomenon of 'jazz as art', i.e. account for it as a distinct social phenomenon.

The spread of jazz is connected with the expressed, but repressed need which White America had for things of that kind (things which had the same social significance as jazz had developed during its formation). Jazz was not sought out as an area of knowledge, nor as an area in which to display expertise. For the mass of Americans it was a very abstract sign, to be in the proximity of which was to signify one's own free, unrepressed, undisciplined individuality. Jazz enabled a mass of people to signify this because as a sign, at a very obvious level, it challenged an accepted sense of authority and discipline. However, those caught up in the spread of

jazz do not make real contact with an already evolved form of life. Those musicians who leave New Orleans to play in Chicago and New York lead a very self-enclosed, hermetically sealed-off existence. They do not in themselves spread the New Orleans life-style. Jazz entered the White American world as a fashionable, rude word (the word 'jazz', at this time had, clear, but repressed associations with 'fucking', just like 'rock n' roll' does at a later time) and as a pretext for and inducement to (syncopation itself was sufficient to induce) what the *New York Times* would have seen as undignified posture and movement in dancing. In other words, for the consumers, the jazz experience has the same significance as it had for Europeans in New Orleans, only it has this significance in diluted form. Just as the New Orleans' consumer could not assimilate what he took to be an orgiastic meaning without disguising the fact from himself, so even more so is this true of the Americans of the 'jazz age' and beyond. To be in a context bearing the label 'jazz' was really sufficient, it was not necessary to encounter jazz New Orleans style; in fact to do so was, often, to take on more than was bargained for. For instance, Louis Armstrong's first appearance in Britain at the London Palladium was a sell-out, but the packed audience, when confronted by Armstrong the perspiring negro constantly mopping his brow with a handkerchief, left in droves. They had come because the event bore the label 'jazz', they left because it went too far; it was more than they were ready for.

The jazz life widens through a manipulation of the label; the label often accompanying music thinly related to the initial stirrings of jazz. Jazz music, itself, was spread mainly by white imitators, black jazzmen being employed more in areas where the tendencies in society were at their most extreme. For example, two of the most important influences in spreading jazz were the all white bands, The Original Dixieland Jazz Band (this band visited England in 1919) and the New Orleans Rhythm Kings, whereas black jazzmen operated in underworld haunts where America's uppercrust

came to soil itself. Milton Mezzrow testifies to this latter point in Leonard's book,

> It struck me funny how the top and bottom crusts in society were always getting together during the prohibition era. In this swanky club, which was run by members of the notorious Purple Gang, Detroit's blue bloods used to congregate—the Grosse Pointe mob on the slumming kick, rubbing elbows with Louis the Wop's mob. That Purple Gang was a hard lot of guys ... and Detroit's snooty set used to feel it was really living to talk to them hoodlums.

Mezzrow's notion of 'really living' is important; it underlines what the identification with the jazz experience was about. However, the 'really living' was ever transformed by moderating influences. This occurred in many ways.

A huge, advanced, capitalist industry was able to grow around a marketable concept of 'really living'. By 1921, 100,000,000 records were manufactured in America and (with fluctuations surrounding the Depression) by 1942 record sales reached 127,000,000.(*ibid.*) Throughout this period the sales of popular music far outstrip the market for classical music. By 1939 the sales proportions are 9:1 in favour of popular music.(*ibid.*) Throughout the period radio and cinema are expanding at the same explosive rate. For instance, by 1927 four-fifths of the American population attended the cinema at least once a week.(*ibid.*) These contexts, plus the similarly expanding dance hall business were the contexts in which popular music expanded and was expanded. The notion of popular music at this time cannot be separated from a general sense of jazz. The music the public required had to be 'jazzy', or 'syncopated' or 'swing' music. Jazz musicians themselves (now full professionals compared with their forbears in New Orleans), whether black or white, earned their living out of playing this kind of music. For instance, the revered Coleman Hawkins was to be found during the depression playing for the, at the time famous, now forgotten, Jack Hylton dance band. The profiteering which motivated the distribution of the concept of 'really

living', became a monopolistic enterprise. The radio stations bought up the phonograph companies, and the film companies the music publishing businesses. Against the background of commercial monopoly there was strong pressure to sell music that both excited (stimulated the demand) and did not offend; the object was to sell to the greatest possible number. The music, therefore, had to be new, fashionable, 'really living', but at the same time refined.

Various musical forms answer to this demand, ranging through White Dixieland, Symphonic Jazz and certain types of Swing. White Dixieland, for instance, traded off the symbols of the South, the negro, the authentic savage, but presented them as the parts of a tropical island idyll. A typical example of this is the 1928 recordings by the Frankie Trumbauer orchestra with Bix Beiderbecke on cornet. Here, a young Bing Crosby sings about natives in Borneo, and 'darkies' who can make music simply by beating their feet on the 'Mississippi mud'. The music's style is jazzy, but distinguishable from Black New Orleans jazz. In comparison the music is not raucous, loud or orgiastic but it retains an expressive element of liberation. The pieces of music do not propagandise enrollment in any social order or project, nor in any way celebrate a form of social organisation; their overall expressive content is one of expressing freedom from the sublimation of self in some larger social destiny. The positive side of this is the celebration of individualism, but the individualism celebrated is of a particular kind. It concerns individual sexual fulfilment, presenting itself in the disguised form of carnal romance, and a personal goodtime, a kind of happy individualism (what Beiderbecke, himself, stood for as a social symbol). As for the rest of experience, it is ignored. The jazz style reinforces the sense of liberation. In itself it is an active rejection of older forms of musical organisation. Moreover, it has clustered around it a set of recently acquired social associations, which vaguely gesture towards the wilder life of a primitive idyll. Features of the earlier music, which do not seem to be present, and which

point to the transformations which have taken place, are a contagious, rebellious hysteria, a sense of send-up or mockery and an exhibitionist eroticism. The modifications in Trumbauer's music are individualism, fun and romance. The Trumbauer music is not negative, it positively constructs private dreams, which are presented as realisable dreams for all of America, certainly for all of White America; but this American dream has to be realised atomistically or separately. The music suggests that a happy, individualised, fun-existence is possible for all, and that this possibility is a challenge to all that is stuffy and restrained. It is this image which is commercially exploited and, therefore, in terms of the American public exploitable. Jazz was a convenient, pre-existing form for the expression of this image. 'Really living', in this commercial setting, is not at the point of interconnection between slaves and masters, or hoodlums and blue bloods, but its attractions can be related to what was sought in these other conjunctions.

The modification of the *'really living' experience* was not just a commercial stratagem relating itself to the threshold of social consciousness. It also sprang from the intentions of some of those who made the music. For instance, Paul Whiteman (set up as the King of Jazz by the media at the time) accepted jazz as a release from repressive mechanisms.

> In America, jazz is at once a revolt and a release. Through it we get back to a simple, to a savage, if you like, joy in being alive. While we are dancing or singing or even listening to jazz, all the artificial restraints are gone. We are rhythmic, we are emotional, we are natural. (*ibid.*)

At the same time this release is accepted, by Whiteman, in a repressed form. As he wrote of his Aeolian Hall concert in 1923,

> My idea for the concert was to show skeptical people the advance which had been made in popular music from the days of the discordant early jazz to the melodious form of the present. I believe

that most of them had grown so accustomed to condemning the 'Livery Stable Blues' sort of thing, that they went on flaying modern jazz without realizing that it was different from the crude early attempts ... My task was to reveal the change and try to show that jazz had come to stay and deserved recognition.(*ibid.*)

Whiteman's notion of modern jazz in this quotation has to be understood in terms of pieces like Gershwin's 'Rhapsody in Blue'. In fact George Gershwin's attitude was very similar to Whiteman's. He is quoted in Leonard's book as having said of jazz,

Certain types of it are in bad taste, but I do think it has certain elements which can be developed. I do not know whether it will be jazz when it is finished.

This attitude was quite general and represents the first conceptual coupling of jazz and art as made by individuals having some social prestige. The critic Osgood wrote in the *Musical Courier* of his experience on first hearing 'symphonic jazz',

Before the first sixteen bars were over the revelation of new jazz had descended upon me. By the end of the tune I was a happy convert.... These gentlemen made music; languishing, crooning music, rude neither in sound nor tempo, music that soothed and yet, with insinuating rhythms, ear-tickling melody and ingenious decorations, stirred me within.... While I had been going about, with my nose in the air, with patronising ignorance, somebody had put music into jazz.

By this time the *New York Times* was prepared to concede as much.

... arranged and played by experts [symphonic jazz] has much about it of interest and even of value, and all unite in condemning the inexpert and over enthusiastic disturbers of the peace.

An important factor in determining the modifying influence

and the form it took sprang from the American college and high school audience making jazz something of its own. Jazz as a 'flash', new, social sign born of a concealed debasement of the European was converted, saved by means of a marriage with the latest, allegedly revolutionary flowerings of European culture, as they appeared, transplanted in teenage American higher education. The names of Debussy, Ravel and Milhaud represented avant-garde 'serious music' for many jazzmen of the period. They attended concerts of 'serious music', they received musical instruction from famous teachers in the classical tradition, and some of them openly experimented with the possibilities of symphonic jazz. The 'serious music' influence did not penetrate very deeply into the music, but it was there, through a commitment to the melodic, and a very conscious concentration on harmonies which take a long time to resolve themselves or remain unresolved. Music showing this influence is full of 'highs' and 'lows'. The music of Beiderbecke and Hoagy Carmichael is of this kind. The titles of their compositions reflect the mood, for example, 'In a Mist' and 'Stardust'. In these pieces we are at some distance from Louis Armstrong singing,

'Now I ain't rough and I don't bit,
But the woman that gets me got to treat me right.'

Many negro band leaders of the period were graduates or came from prosperous middle-class backgrounds, for example, Lunceford, Henderson and Ellington. Many of Ellington's compositions exhibit the harmonic preoccupations I have just been mentioning. 'Highs' and 'lows' are very evident in pieces like 'In a Sentimental Mood' and 'Sophisticated Lady', and a conscious concern with wandering harmonies is ever present: a strong example of this occurs in bars 23 and 24 of 'Sophisticated Lady' where Ellington goes through the chord changes G, D dim, Cm, Eb7, D7 whilst the melody line plunges from B above MC to MC and then ascends to E, one octave up, before plunging again, this time to F sharp.

Where, then, the jazz experience in society involves taking up jazz music, the process involved, is not only one of watering down in accordance with commercial dictates; it is, also, a positive conception of transformation. The excitement of the depraved is entered into by containing it. The containment is achieved not by abolitionist tendencies, nor by imposing on it a traditional sense of order, but by allying it with a specific sense of the bohemian and avant-garde. There was reverence for the art experience amongst many jazzmen. The clarinettist, Pee Wee Russell, provides a telling illustration of this, when describing, in Hentoff's book, how he felt when, at a Carnegie Hall concert, in a box paid for by Paul Whiteman, one of his fellow musicians kept falling off his seat in a drunken stupor. 'You see, we were ashamed and were conscious of the other people at the concert.'

It may be doubted whether New Orleans' Buddy Bolden would, in similar circumstances, have been as shame-faced. We are dealing with a social group which is a 'cut above' the 'proletarian rabble' and often there is a tradition of classical music in the background. For instance, Paul Whiteman played violin in both the Denver and San Francisco Symphony Orchestras and Beidebecke's parents had ambitions for him as a concert pianist (an early influence he never quite lost despite his prowess on the cornet). The milieu for the music was very much high school and campus gigs. The Austin High School Gang first heard its jazz not at The Deuces (Chicago low dive) but the Spoon and Straw (ice-cream parlour), listening to records by the New Orleans Rhythm Kings. Goodman, though not from a wealthy background himself, plays, as a teenager, for students at Chicago University and North Western University. (In fact, the whole Goodman success story has to be measured against the growth in American higher education and its production of, to a degree, a new autonomous social group. The growth of Goodman, Artie Shaw etc. and Swing relates to jitterbugging American teenagers and, more influentially, teenage rioting).

We have located, then, a certain cohesive group, within the

history of jazz, involved in playing jazz, which is composed of white, middle class youngsters who have some respect for 'high culture' and some knowledge of the tradition of classical music and contemporary European serious music. However, the social milieu is only a third of the story, for it has to be related both to the commercial growth of jazz and the excitement of American low life. It is in the latter setting that the coloured jazzmen often find their environment, scratching out a living between these engagements (often very temporary in character) and the making of the special category of 'race records' (records exclusively bought by coloured purchasers). This is not to say that jazz by the coloured jazzman is all of a piece. There is a real distinction between the coloured player meeting commercial demands and the coloured player playing on a more private basis. This contrast constitutes the reality of the black jazzman, and it relates to earlier ambiguities within jazz experience; it relates to them as a fragmentation of them. But more of this a little later, for what is being explored, now, is how the white American, middle, lower middle class jazz setting relates to this other setting for jazz. What is clear is that the two settings are separate. This is testified to by two facts. Firstly, it is testified to by the resentment felt by black musicians for what they considered to be white imitators; the white jazzmen were commercially more fortunate in having wider commercial outlets. Secondly, it is testified to by the difficulties which beset mixed, jazz groups on the road. For instance, the difficulties experienced by Billie Holiday on the road with white bands, or the difficulties often experienced by Benny Goodman in taking Hampton and Wilson with him. For the white jazzman then, jazz was concretely present within the total American environment as a feature of low life (or life 'really lived'). To be involved with jazz was to be on the fringes of what passed for excitement in American Society. In this way jazz was not only something to be saved and brought within the confines of 'good music' (by coating it with a thin veneer of 'exciting' musical modernism; thus not

negating it as something signifying excitement) but it was
also, in its turn, sought as exciting salvation or as giving the
feeling of this. Jimmy McPartland of the Austin High School
Gang makes this clear in Hentoff's *Hear me Talking to Ya*.

> It was lucky for me I got in with that gang, because as a boy down
> there on the West Side, I might easily have been mixed up with a
> different kind of mob.
> So for me, and perhaps other Austin guys that got the music bug,
> jazz supplied the excitement we might otherwise have looked for
> among the illegal activities which flourished then in the neighbour-
> hood.

For the white, middle class, lower middle class youngster
(e.g. McPartland's father was a music teacher) who was to
enter the jazz world as a performer, and in the process
enlarge the dimensions of that world, jazz presented itself as
a complex phenomenon. There was jazz as a form of music
having a history. This was known about but not known in
depth. In this context there was a sense of jazz constituting a
genuine, indigenous folk music, and something which, in
accordance with recognised practices in serious music, could
be utilised to produce a unique American music (i.e. it could
be utilised once modified). There was jazz as a universalised
racy value, which the whole of the post war Capitalist world
was in on. There was jazz music, as something being spread
by White Dixieland and its offshoots, the process being
mediated by records and the radio. There was jazz music
played by black musicians, which offered itself in two forms,
the commercial form and the jam session, both forms arising
for the most part in a gangster dominated, night-life scene.
There was jazz music as symphonic jazz. These various
aspects of jazz, like the total, social conception of jazz,
presented themselves as liberation and excitement, as unre-
pressed 'really living'. To measure this it helps to contrast it
with the social significance of jazz today.

Jazz as an activity for a small coterie of addicts, no doubt,
is still thought of as 'real living' but this would not be its

general social significance. It is to this general, social signifi-
cance that the white, potential jazz musician of the 20s and
30s responded; the response being channelled through some
or all of jazz's various interconnected and sometimes discon-
nected, evolving forms. What I wish to suggest is that all
these living layers of jazz experience duplicate structurally
(i.e. in the way the layers relate to each other) the original
structure of New Orleans jazz (a less fragmented set of
experiences) and that the lived, personal ambiguities in the
New Orleans scene are lived out later as the social contrasts
between the different layers (the layers themselves having
associated with overlapping but differentiatable social group-
ings). The objective of the present line of discussion is to
describe the modifying, repressive impulses of those making
jazz, from the spreading jazz of the twenties up to the end of
the Swing era, but this is something extremely complex to
describe because of having to relate individuals to the
proliferation of so many different but connected forms.

It makes sense to say that the early jazz was a social
presentation of *disguised orgy* (sought out as debasing and,
therefore, experienced as liberating). For reasons I have not
gone into, Americans of the Jazz Age and beyond, were open
to a general proliferation of some such experience. Jazz as
music, dance and fashion was an appropriate vehicle for such
a proliferation. However, the forms of disguise had to
convince the various thresholds of social consciousness
throughout America, and from this viewpoint it was as if
New Orleans Jazz was naked orgy (totally unexpurgated
filth). In general the taboo on social thought and actions were
so great that to call any social event a *jazz event*, as long as it
was not too obviously not a jazz event, was sufficient for
commercial success (e.g. Al Jolson in the 'Jazz Singer').
However, there were other responses. There was the response
of saving jazz, as naked orgy, by incorporating what were
deemed its best elements into a thin conception of sym-
phonic, orchestrated music. Socially this was a response
having important repercussions because a great number of

commercially successful ballroom orchestras, throughout the Western world, were modelled on orchestras like the White-man orchestra. Such orchestras might include a 'hot' music-ian for a few well-mannered jazz breaks, just as the White-man orchestra incorporated Beiderbecke for this purpose. In this music there was a concession to the American fear (already documented) of the corrupting influence of jazz. The musical form into which the jazz elements were slotted (one major transformative ingredient was light syncopation) was largely derived from nineteenth century, romantic, 'serious', 'light serious' music. Another response was to recreate the original music only in sweetened form, or by emphasising its 'sweet' as opposed to 'hot' elements. This was a more open flirtation with the 'naked orgy' value of the music, but what was already disguised was further disguised. Finkelstein, in his excellent book *Jazz: a People's Music*, shows how the 'sweet', 'hot' contrast permeated New Orleans jazz and, thereby, adds weight to my argument about New Orleans jazz.

> One of the characteristics of New Orleans music, contributing largely to its variety and beauty is the mixture of different musical language, the interplay of the 'hot' and 'sweet', blue and non-blue. This fazes the theorists of pure-blues jazz, who either ignore the mixture or assume that the non-blue elements were 'subconsciously' assimilated and immediately 'blued' or 'Africanised' by the per-formers. It reveals, rather, that the interplay of the two languages was a most sensitive, highly conscious musical operation, and it is precisely the artist who is most 'folk' (or musically 'pure' as the theory goes), who will often play a non-blue melody straight and with great pleasure in it.

In white Dixieland the 'blued' elements are 'sweetened', but the excitement is still there through the active working upon the contrasts (remember the contrast adds up to the feeling of the debauching of white values, and excitement is generated simply by playing with the contrasts). White Dixieland is a jazzy music for having a 'good time', but it has a more intellectual side as well. It attracts into it young, white

Americans who are in, or have connections with, higher education. Here, we have backgrounds that make for some commitment to 'serious' music (the élitist European tradition). However, the kind of individuals of this order, who are drawn into jazz, tend, in serious music, to identify with the avant-garde music, the music which selfconsciously breaks with a settled tradition in European 'serious' music. This avant-garde European music is not only taken up because of its bohemian excitement, but also because of its consciousness of jazz, employing as it does some miniscule jazz influences in its compositions. This jazz tinge is one of its exciting properties. A passing and respectful knowledge of the revolutionary happenings in 'serious' music influences the kind of jazz that certain jazz musicians produce. In this, then, excitement results from taking up the original value *jazz* at some close proximity to its roots, and saving it, and oneself, by imposing certain refinements upon it, but imposing the refinements is, in itself, an excitement not only because of what is being refined by them, but also because the veneer, though being morally upright (connected with 'art') is new and revolutionary and a break from what would have been regarded as European stuffiness. In this way one saves oneself from the temptation of total immersion in American low-life (never a real psychological possibility for most of those who felt themselves exposed to the temptation) and at the same time one redeems the low life, by a presentation of it through a respectable (the art connection) but chic (new, unstuffy) veneer, like stripping down an old wooden chair, and coating it in a very modern, but tasteful lacquer. The net effect of such a life, lived by musicians, was to produce the sense that one was 'really living', where 'really living' was achieved by hovering between seamy America and art.

Beiderbecke is typical of this. He lives the dreamy other worldly life of the artist at the same time as the dissolute good-time life of the jazz age. However, in describing this particular mode of modifying the jazz tradition (and this

contribution to its evolution) certain strands still need to be woven into the account. Thus, the musicians I am describing did not singly look back to New Orleans jazz and set about modifying it. Jazz was an ongoing set of experiences, and it was a set of experiences having a pronounced commercial expression. The commercial expression was itself (as already discussed) a modification of original jazz or, perhaps better, a utilisation of some of its elements as racy modifications in their own right, of a popular idiom (popular classics simplified, and derivatives). Therefore, the jazz musicians I am describing operated in a market which demanded such a product. Their modifying inclinations were, then, exercised upon an already highly modified jazz (in fact most of it now would not be regarded as jazz, though at the time it certainly was). On top of all these interactions was the interacting presence of black jazz. Black jazz as orgy was not simply an actively recalled debauched Arcadia, which had taken place in New Orleans in a mythical past, it was more importantly for those in the know an existing 'hot', sexy music to be located in the night life of the underworld. It was a 'sweetening' of this that many white musicians were drawn into. To be part of that world but be apart from it. Of course, different musicians responded differently and some were more inclined to be a part of, than be apart from (e.g. Eddie Condon).

What I have tried to explain so far is how the proliferations of jazz occurred in 'sweetened', cleaned up and therefore highly modified form, and how this process answered the demands and desires of a white audience and white musicians who wanted to be jazzmen. What I have been trying to underline in this account is that the value *jazz* looming beneath all the modifications, was the infectious quality. To think of oneself as a jazzman, to dance to jazz, to be part of the jazz age, this was the contagion, which appeared in many disguises dependent upon the repressive needs of the participants. However, jazz was, despite its being a generalised notion, none the less a more specific social identification of a

value than the more general, though still socially identifiable, objective of 'debauchery' upon which the seeking of the jazz experience was dependent. In time *jazz*, as a value, was to wane, whereas, the more general objective was slowly but continuously pursued, feedng off other things.

Jazz, then, is a presence, which is continuously surfacing in the various forms of commercial music of the period. It is a subterranean, unthinkable excitement which is revealed through its concealment. It is a deep flowing, foul river and the various forms of concealment are its artificially constructed irrigation ditches. Of course, it was not necessary that there should be some *actual*, deep base to the jazz-flavoured frolics of the period, this is to say it was not necessary to there being an active notion of it. However, such a large process in society, manifesting itself in a spectrum of attitudes, did give rise to an actual social form, which was easily interpretable, by those who sought such a base, as the required deep base for the total social experience of jazz. By this I mean there was locatable, in the depths of society, a distinct stratum which was black jazz. It is this which now requires description.

In the depths we do not find unambiguous sordidness. In order to achieve understanding it is necessary to rethink, for a moment, the significance of the early jazz for the black man. It was the project of not meaning what one was saying, and at the same time implying an undermining meaning which one did not say. This was the significance of the music for blacks. However, when we move on to the spreading of the jazz experience throughout the capitalist world, we find the jazz, required of the black man commercially, leaves scant space for the positive act of withdrawing from meaning what is said. This difficulty is not experienced all at once, but it is a gradually changing practice which is not offset socially by commercially acceptable examples of scat singing (e.g. Armstrong) of material in the popular idiom. The black musicians fulfil the original structure of the music by dividing it up, by a fragmentation of it. The fragmentation is not

so much one of dividing up a given and determinate musical style, as one of, in one context saying the acceptable meaning whilst constructing (the inventive side) another context, which takes away the acceptable meaning as meant. The acceptable meaning is, of course, for whites the liberation from repressive ideology, though this meaning is for other forces in white society unacceptable (the threat to the social fabric). However, this acceptable meaning cannot satisfy black consciousness, for its problem is not one of achieving liberation from its own, anachronistic (i.e. economically) repressive ideology. Its problem is one of getting back at white society without getting beat for it. It can hardly gain satisfaction from what gives white society its kicks. The two contrasts are concretely specified by the commercial gig (whatever and whenever, though most often on the fringes of white social experience) and the jam session. The jam session is a way of saying that as a professional musician the negro jazz musician is not for real. However, the jam session is no more important than the gig because the two feed off each other. The point of the jam session is to point to the gig as not being for real. It is for this reason that, what has been seen as the puzzling phenomenon of the negro musician taking up the commercial music of his day as a basis for jazz, becomes explicable. Thus, it has been alleged (Finkelstein) that a lot of fine musical material is utilised in New Orleans jazz (e.g. 'Panama') and that the same cannot be said of material utilised in later jazz (e.g. 'Embraceable You'). The reason often offered for the change around is commercial pressure, but this by itself does not explain the intrusion of white, commercial music into the jam session. It is when the jam session is linked to the commercial setting that the use of white, commercial music becomes clearly intelligible. It is when what jazz is *is* living to imply the contrast between the contexts that the dropping of earlier standards (i.e. standard numbers) can be undertaken lightly. The ambiguity, which was written into one and the same music in New Orleans, later, is no less present, but it is

present through social fragmentation. The jam session is not
what it is all about except in the sense that the jam session is
created explicitly to *mean* this is what it is all about, this is
what is done for real and not the other thing.

Gene Roney provides a telling illustration of this in
Reisner's book on Parker,

> They were jam sessions held every morning. The ones Bird and I
> attended faithfully were held at the Reno Club, where Count Basie
> was playing. Basie had a nine piece band and they worked a tough
> schedule—from 8.30 to 5.00 in the morning. After that the jam
> sessions would begin. (Reisner, *Bird: The Legend of Charlie Parker*).

To think oneself into this situation, as audience, is to feel
the insult. Having paid for the excitement of jazz one finds
that the musicians are hanging around waiting for you to go,
whereupon the real thing gets underway. It's like going to a
party where everyone is waiting for you to leave so that they
can get on with the *real* party.

What actually happens, in the jam session, is distinguish-
able from New Orleans jazz in so far as the music being
worked upon has different significances. Thus, white, com-
mercial music is jazzy (what that implied, at the time, I have
already tried to specify) and it is concerned with, what earlier
I called, carnal romance. The looser, somewhat less uptight,
white society is competed against in the jam session; the
negro out-seduces the white crooner and turns the quickstep
into orgy. But the meaning is not just seduction and the
orgiastic, it is rather the competitive meaning. The whole
point, when Lester Young or Coleman Hawkins blow
'Embraceable You', is that compared with standard, white
renditions of the number their seductiveness is so much more
expressive. This, at the time, is not obviously apparent to
white ears because seductive overtures could only be tolera-
ted where there was the safety of restraint.

The competing against white society was not realised
within the black musicians' world as a collectivised, group
project. The element of competition involved, also, the

internal relationship within black, jazz music. The individual objective was to achieve success in being against white society. This did not mean refusing to identify with any white objectives or social goals. White society was itself internally gripped by economic competitiveness both on a personal and social basis. To seek the trappings (all the negro musician of the period was at all likely to get) of wealth (e.g. 'flash' clothes, money to throw around on girls etc.) was both to identify with the system of white, American society and, at the same time, compete against individual whites. It was also, however, to compete against other negroes. To be successful in white society's terms was, also, to be successful in competing against whites, and to be successful at this was to be successful as a negro. The 'flash' negro then, with an ultra seductive style, was the competitive negro. The more seductive were one's choruses the more one outdid white society and the more one succeeded, against other blacks, in the black project of outdoing whites. What I am trying to emphasise is the fact that there is, on the part of black jazzmen, a deep entering into the romantic sentimentality of the commercial music of the period. The notion that the music of the period was simply used by coloured players, as a vehicle for the tracing of musical arabesques, does not stand up to the reality of a coloured musician soloing (e.g. Ben Webster). To allow, however, for the fact of an entering into the spirit of the music is not to situate the black musician as a gullible absorber of white commercialism in music. The black musician competes at the level of the music's significance to the consumer (i.e. in the area of its liberating meaning). This is a side to the music missed in a dismissive musicological treatment. It is true there is a turning away from the straight-forward, melody line of the pieces played, and that the pieces are often used as a pattern of chord changes, but the style remains one of displaying seductive technique. The discard-ing of the melody and the fastening onto the chord pattern is, I am suggesting, part of the general project whereby there is a disassociation from the acceptable. White, commercial tunes

are played but not played, and in not playing them they are rendered more seductive or more orgiastic. Between the commercial performance and the jam session we find the contrast between the acceptable and the unacceptable disproportionately exhibiting itself, depending upon how commercial, or how free and open the context. Of course, the contexts themselves, especially the commercially viable ones, are determined by them being contexts in which black musicians are accepted. The music demanded by these contexts is, then, already, by the general standards of American commercial music, unacceptable. It is the deep base against which all other jazz experiences measure themselves. However, its reality, as I have tried to indicate, does not compare with how, as a measure, it is used. As a measure it represents obscene excess, in reality (i.e. for the negro) it is an ambiguous expression signifying competitive but sarcastic compliance. However, in so far as it is a movement which elaborates a rejection of the white, musical form, and is thereby a rejection of what that form means socially, then it gathers to itself potential excitement for those intentionally rejected by the movement. The most exciting party is the one you are not allowed to go to.

To this point I have tried to sketch in the development of jazz up until the middle of the 1930s. It is clear that by the time we reach the 1930s, jazz is a distinguishable phenomenon from the early jazz in and around New Orleans, though it is something linked to what was earlier. My objectives in specifying this development have been various.

Firstly, there has been a methodological objective, namely that of indicating the complexity, and the kind of complexity it is, which has to be described. There has not been some essential thing, which is jazz, which has been described. An account which seeks jazz in this way works from a preferred definition as to what jazz is. In contrast, it seems to me preferable in specifying what jazz is, and was, to delineate what at different times social consciousness has designated as jazz. When this is done, for the period in question, we find a

number of distinguishable social processes exhibiting similar structures and all of them interacting with each other in a multiplicity of ways. As this complex has emerged it has been my intention, and is my recommendation, not to reduce this complexity to some systematic formula, but rather to allow it to unfold as something lived by so many different individuals in many different ways. In a way, the methodology has been a rejection of method, and an insistence on the fact that what is lived and concrete is so tangled that it cannot be rendered by a point by point (a), (b), (c) sort of formula. This is not to say it cannot be known, but the knowing, which is possible, is not a definite knowledge, it is instead, an imaginative reliving of what was lived, and this leaves one with as many loose ends and dissatisfactions as the life lived and, therefore, known. However, this is not to excuse any sparsity of detail in the present account, this is excused differently by the scope of the enquiry. What I have tried to indicate is the way a more ample account should be conducted.

The second objective, which relates to the thematic centre of this essay, has concerned bringing into focus the first actual social processes in which a relationship between jazz and art gets posited. I think it is clear that this positing is quite distant from the different, sometimes opposed, strands within what, by the mid 1950s, has become the orthodoxy within jazz i.e. that jazz is an art form. By the 1950s, a consciousness of jazz as art includes the belief that jazz is an art movement with an unrecognised (certainly by the general public and also by the established art fraternity) history. In this movement, the history of jazz is being sifted like some ancient civilization for its great works of art, and involvement in the movement includes, as a competitive motive, the desire to accumulate esoteric knowledge. The most straightforward illustration of this is the growth of discography, as it concerns jazz, (a growth which had been taking place since the middle of the 1930s) although the motive has a more complicated and more socially diffuse nature. The earlier appraisal of jazz as art was much more the view that jazz was

a possible *art form*, or that jazz could be turned into art. The subsequent view was not the locating of successful attempts at achieving objectives prescribed by the earlier view. The earlier view was not, then, the sudden realisation that what lay all around one, namely jazz music, was, in fact, as yet unrecognised art music, rather it was the view that jazz was a music that could be turned into art by the creative efforts of schooled musicians. This view did not result from deep, aesthetic deliberations as to what could, or could not count as art; rather, for certain groups of people, it was a view which fitted what was specific to their position in society. Jazz is a form of life having a deep base, and the deep base, constituting the most authentic area of jazz as art, was not within the limits of the social consciousness which first drew the concepts of jazz and art together. In terms of this first view of jazz and art, jazz moved into art as it moved away from the deep base, and moved towards (as a set of musical techniques i.e. techniques formally definable) the world of art as normally constituted. This, then, as a movement, is not one which particularly involves the coloured player. The coloured player, as someone confined to the deep base, is obviously enough not enticed by this movement into a consciousness of his activity as art.

A third objective in setting up the account, as it has proceeded thus far, follows on from having specified the first stirrings of the art movement in jazz. Thus, we can see that the tradition, of regarding jazz as art, does not proceed, in the first place, from expert interpretation of a phenomenon which, until that time, had eluded intelligent assessment. Whether one agrees with my general account of jazz or not, no-one today would accept the jazz/art view which predominated in America during the 20s and early 30s. In fact most of what was at that time produced under the jazz/art banner, would today count neither as art nor jazz. I have argued that later interpretations, of jazz as art, constitute misinterpretations of the actual jazz movement as social experience. Thus, the evidence accumulates for the view that the interpretations

of jazz as art do not function as true knowledge of jazz
(which is their ideological stance) but rather they function as
unconscious, justifying disguises for entry into jazz experi-
ence (itself multifarious in nature and constantly changing)
from various social bases. In time, as I shall try to indicate,
the interpretation of jazz as art, though various in nature,
takes over the reality of jazz, so that for those who make jazz
and those who listen to it (and those for that matter who sell
it) to be in jazz is to be concerned with art experience. As
this becomes the prevailing conception of jazz, so jazz ceases
to be a popular idiom and instead becomes increasingly
complex and inaccessible. This is not to say that the value
jazz had to previous generations disappears. There is no
fundamental structural change affecting society which coin-
cides with the immersion of jazz in art. The value jazz had to
previous generations is still present, though appearing now
under the label of Rhythm and Blues and its offshoots and
derivatives, or rather R and B constitutes the deep base
against which the popular idioms measure themselves. At this
point jazz as the value it was dies. This viewpoint on jazz is
well reflected in Philip Larkin's introduction to his *All What
Jazz* (P. Larkin *All What Jazz,* London, 1970, pp. 13-14).

> By this time I was quite certain that jazz had ceased to be produced.
> The society that had engendered it had gone, and would not return.
> Yet surely all that energy and delight could not vanish as completely
> as it came? Looking round, it didn't take long to discover what was
> delighting the youth of the sixties as jazz had delighted their fathers;
> indeed, one could hardly ask the question for the deafening racket of
> the groups, the slamming, thudding, whanging cult of beat music
> that derived straight from the Negro clubs on Chicago's South Side,
> a music so popular that its practitioners formed a new aristocracy
> that was the envy of all who beheld them, supported by their own
> radio stations throughout the world's waking hours.

It seems to me that the next substantial and influential
development in jazz, which is concerned with the identifica-
tion of jazz as art, has a European base. This is a process that
I have found more difficult to research. One of the reasons

for this stems from the fact that jazz research is, arguably, the important contribution made by Europeans to the jazz tradition, and that, therefore, its function has been one of spotlighting something other than itself. Therefore, as far as secondary sources are concerned, it is difficult to find material on the history of the European experience and criticism of jazz, apart that is from the odd account, here and there, by people in jazz of what it was like, throughout the 30s, 40s and 50s, to get involved in jazz (e.g. Humphrey Lyttelton's *I Play as I Please* and *Second Chorus*). As I am aware, therefore, the reception of jazz in Europe is an area requiring investigation. What would be uncovered by such research would, no doubt, show some set of overall similarities between different national experiences of jazz whilst also showing interesting national variations. What such research would need to show is how the European reception of jazz, despite some general popular response akin to what one finds in America, gave rise to a conception of 'real jazz' as that coinciding with what has been referred to as the deep base. In clearer terms what has to be explained is how some Europeans took up jazz, as made by coloured musicians, and held it up as 'real jazz' as opposed to another concept emanating from Europe (the commercial use of jazz techniques) and how, further, the 'real jazz', as it was established as being, was not only held to be 'real jazz' but more than this music worthy of serious musical consideration i.e. an art form. One simple explanation of this would be that certain Europeans just saw that this was so. However, as I have shown, seeing that something is art has never been a matter of seeing that some fact was the case, like seeing that an object possessed some clearly identifiable property. Therefore, it is likely to be more profitable to seek an explanation in the general social background, than in some presumed, but impossible, perception of truth.

As it has been traced through, the jazz feeling in America has shown itself to coincide with a sense of being American. Despite opposition to jazz in American society, the

predominant trend was towards the proliferation of jazz values. The being American, in this sense, has to be understood alongside what it was not, namely, being European or having European aspirations. This sense of European values was not mythical, although the realisation of these values in the American context was a variation on a tradition which was, anyway, variously expressed in Europe itself. Against this background, then, it is not surprising to find stiffer European resistance to jazz music (meant in the loosest sense) in Europe than in America. By resistance, here, is meant not just propagandised opposition from groups that would have nothing to do with jazz music, but also resistance by those who used it and often profited from it. American popular music, as we have seen, uses the initial jazz elements in highly modified form. European popular music becomes a *modified* form of American popular music, where *American* becomes the exciting contrast which is allowed to infiltrate under censorship into European social experience. The remoteness of coloured jazz from popular music in the States is extenuated in Europe, although, where European opposition is at its most repressive, so identification of coloured elements, as an obscene element, is made. Some illustrations of this. In Britain the BBC has a striking record of banning at one time what, at a later time, it allows to be played *ad nauseam*. In the 30s the BBC, in its repressive drive against what it took to be the excesses of popular music, singled out, for censorship, the specifically negro features of the jazz-tinged popular and dance music of the period. Thus, no-one broadcasting was allowed to refer to dance music as being 'hot', 'hot jazz' being very much negro jazz. Moreover 'scat' singing, as performed by Nat Gonella in homage to Louis Armstrong, his idol, was banned also.

In Germany the Fascist regime was more explicit. It was made an offence for Germans to play dance music containing negro elements. The negro elements were specifically identified both in terms of what they were as technical items, and as being negro. As a consequence, such effects as the long

drawn out off beat, and the inclusion of riffs, were banned. I suspect that for the mass European mind the idea of there being a negro content, in anything other than an idyllic form, to jazz or 'syncopated music' (as it was known) would have been quite unthinkable as something to identify with. The repressed item in the experience was what was taken to be American (i.e. an item thinkable, but repressed). Thus, the spread of jazz-flavoured, popular music in Europe takes place without a capitulation to American music makers.

In Britain, for instance, the focus of musical attention is on British dance bands. It is instructive, in this connection, to inspect the Melody Maker's publication to celebrate its 50 years of covering popular music. This publication contains a detailed review of the Melody Maker's headlines over the years. Throughout the period I have been discussing attention is concentrated upon British dance bands (Jack Hylton, Jack Payne, Geraldo etc.). What constitutes for us, now, the main developments within the history of popular music only figure marginally in the Melody Maker's coverage of the times. As one reads through the celebration copy one has a sense of the compiler ransacking the pages of past Melody .Makers to find items that coincide with the accepted history of popular music (a history which does not itself coincide with what was popular in its time). The dance bands of the period play in hotels and they play for ballroom dancing. In Britain the top bands are all engaged by top London Hotels, and it is from these bases that they broadcast. The London scene is mirrored in the provinces where every hotel has its resident dance band. The ballrooms are open to the public, and thus for the patrons the same sort of contrast as in New Orleans Condé Street Ballroom obtains, although in highly modified form. The world they enter is the world of hotel life, a context which for most of them is elevated and beyond their normal reach, whilst the music they come for, and the intimate one to one dancing they go in for, has the rum-te-tum of syncopation. The excitement of syncopation, however, is rendered acceptable by the 'high class' setting in

which it takes place and also by the interspersing of waltzes, which, by allowing the patrons to indulge themselves in emotional wallowing, inspire a sense of being cleansed, or made pure, by the seeming sincerity of the feelings indulged in. The excitement of syncopation was the excitement of a miniscule throwing off of dignified posture, as prescribed by official European values; it was, also, the excitement of identifying with the fashionable, latest, American experiences as they were conveyed to Europe largely by means of the spread of cinema.

It is against this popular orthodoxy that certain Europeans begin to talk of 'real jazz' and to talk of 'real jazz' being art. Clearly, to articulate in this way presupposes some kind of intellectual background. France is an influential centre in this connection in the shape of critics and discographers like Panassié and Delaunay. I suspect the individuals involved are counterparts to the young people who, in America, coupled jazz and art. The difference is that in America there was a continuing tradition of playing to join, whereas in Europe, in the first instance, it was more natural to listen than play. Against the reality of many different forms of jazz being played (all at different commercial levels) it was possible to frame the project of turning jazz into art by playing it through some set of modifications. In Europe, in the first place, there are the dance bands playing modifications of American popular music. These bands from time to time include a 'hot' number, or a 'hot' musician who occasionally makes a 'hot' break. For a long time, for Europeans, this is the nearest they can get to hearing the 'live' (apart from occasional American visits which were curtailed by Union banning) music against which American popular music (albeit unconsciously) measures itself.

Philip Larkin testifies to this

This happened by way of the dance band, a now vanished pheno-
menon of twelve or fourteen players (usually identically uniformed)
that was employed by a hotel or restaurant so that its patrons could

dance. Their leaders were national celebrities, and had regular time on the radio: five-fifteen to six in the afternoon, for instance, and half-past ten to midnight. They were in almost no sense 'jazz' bands, but about every sixth piece they made a 'hot' number, in which the one or two men in the band who could play jazz would be heard. The classic 'hot number' was *Tiger Rag*: it had that kind of national anthem status that *When The Saints Go Marching In* had in the fifties. Harry Roy had a band-within-a-band called The Tiger-Ragamuffins. Nat Gonella's stage show had a toy tiger lying on the grand piano. Trombonists and tuba players became adept at producing the traditional tiger growl. I found these hot numbers so exciting that I would listen to hours of dance music in order to catch them when they came.... (*All What Jazz*, Larkin)

In Europe there are odd examples of bands playing what would now be recognised as jazz music, but they do not constitute a significant enough social nexus for a general direct possibility of making the music. The few bands there are perform in remote social areas, like the universities, and, it needs to be remembered, the expansion in higher education in Europe is slower than in America, thus such experiences are not generally available. Therefore listening to what is to be set up as 'real jazz' is mediated by the 78 rpm record or foreign radio stations. However, such records are not readily available, the main bulk of records available being by British musicians or imports of American commercial music. The records sought by jazz buffs are largely 'race records' and these are not that easy to obtain by whites even in America. The realisations of the desire to listen to such music produces, therefore, esoteric minority coteries. This does not necessarily run against the desires of those who enter this minority world. It is, of course, part of the European theory about jazz that it is a form of music which is significant enough for everyone to attend to, but nonetheless there is a 'way out' satisfaction about the fact that very few, in fact, bother with it.

Philip Larkin again makes the point:

In the thirties it [jazz] was a fugitive minority interest, a record heard by chance from a foreign station, a chorus between two vocals, one man in an otherwise dull band. No one you knew liked it. (*ibid.*)

On what basis, therefore, may we suppose that the desire to hear 'hot jazz' originated? For what social needs did this music seem an appropriate object? I suspect that the kind of individuals who get caught up in it (although my evidence for this is not well-researched) are both anti-American and against commercial popularism, and yet open to whatever is 'way out', challenging, 'really living'. They do not capitulate to American-style popular music and the reason is because of a real background commitment to the art concept, which, ideologically, sets up a divide between behavioural forms required by the highly commercial music and those forms of behaviour and attitude required by art. However, the commitment to art is, questionably, open to the interpretation of effeminacy and obedience to the values of the social system (e.g. succeeding in the higher reaches of education, by doing what one is told to do, in order to be held to have understood the history of the art tradition). To show, then, a commitment to jazz music, as it appears within what is the deep base to the whole social jazz experience, as part of one's commitment to art is to offset this interpretation. To be interested in 'hot jazz' is to be interested in what goes beyond the threshold of excess as comprehended by the most dashing, philistine trendies of the period. Larkin testifies to the fact that he, as an academically successful young man, was drawn to jazz music because of its *'bad reputation'*. It is also the case that in identifying with American, deep-base jazz the European was identifying with that, in America, which was intentionally anti-American (i.e. scornful derision of white, commercially successful society) and that which was anti-American, in being a morally-condemnatory example of the harsh inequalities that American, brash, commercial society led to. Moreover, to identify this aspect of American society as art was to make oneself seem anti-American, for the

American ethos as understood by Europe's élites stood for philistine commercialism, and commodity production over against real values (i.e. traditional European values as they were understood). The Adorno position looked into earlier is indicative of this attitude, although for him jazz does not have the special art-status. These particular facets of the anti-American attitude, which certain forms of jazz music were able to satisfy, were facets appealing to individuals having leftist inclinations (e.g. the attack on racial inequality, and the hostility to the proliferation of American style capitalism).

These then are some of the strands which, I suspect, make up the early European based commitment to certain forms of jazz being art. In due course, this minority European commitment becomes an orthodoxy about jazz both in Europe and America, so that what is accepted as jazz is that which is in accordance with these preferred forms. This movement sets up the requisite European practice, which leads eventually to the possibility of European jazz. The fact that the movement is populated by those connected in various ways with Europe's various social élites makes it not at all surprising, as the media at the time was often unable to see, that jazz in Europe was not made by Europe's 'proletarian rabble' but by individuals having some social status. For instance, in the days of Lyttelton's prominence in popular culture, the press could not get over the fact that here was an old Etonian ex-Guards officer and blue blood who spent his time playing jazz. What I am suggesting is that, given the background to jazz experience in Europe, it is *not* surprising, and is what one might expect.

What needs to be examined next is how this interpretation of jazz as art, which as we have seen leads to a misunderstanding of what jazzmen were up to, becomes the contagious, determining influence.

A number of significant events and developments coalesced so as to provide the explanation. There is the development of swing, as a white big-band phenomenon, which

involves mass teenage hysteria and considerable commercial rewards for those perpetrating the music. There are the American musical contacts with Europe brought about by the specialist European interest in certain forms of American music and also by the war. There is the development of Bop and the associated cultural experiences. There is the short-lived revivalist era and its associated cultural forms.

Because of what America stood for to the establishment in Europe (Henry James' novels contain illustrations of what I mean in its earlier forms), and because America contains, despite its reputation, those who aspire to Europe's taste and evaluations, it is not surprising that the European interest in something specifically American, as being worthy of serious European interest, excites a sympathetic reaction in America. This is not surprising, but at the same time there is an element of farce in the situation. Negro jazz, which is the send-up of the European presence in white American society, is recommended to Americans by Europeans as being in accordance with the highest European standards, and on this recommendation is accepted by Americans as being so. This sense of European approval produces in America individuals who stand to what is now emerging socially as 'real jazz' as do the European, non-playing officianados. Connections are established between the European and American areas of critical activity. This, then, is one way in which the minority European orthodoxy gains ground.

This view of jazz, this special sense of 'jazz', which becomes what jazz is, also makes inroads into the world of coloured players. The great popular and commercial success of swing is confined to white practitioners, despite the big-band techniques being taken over from the world of coloured music. The white bands make full emotional use of riffs, they incorporate the jam session as a special, theatrical event within their programmes, signifying thereby where the party really is at, and they cover numbers put out by coloured bands (e.g. Goodman covering Basie's One o'clock Jump). In other words the success of swing is based on a commercial

use (therefore necessarily, at the time, a white use) of the elements within the deep base. Following on from the first white assimilation of jazz experience, white consciousness is by this time prepared for a more thorough-going capitulation to the orgiastic, a more thorough-going dismantling of repressive uptightness. It is this American attitude which is responded to with some awe by Europeans when they ('the Yanks') come to Europe during the Second World War. Europe feels the Americans are freer, looser than Europeans, that they 'don't give a damn'. Their ultimate antithesis in Europe is the style of the German master-race society. There is a feeling that the Americans ought not to win because they seem to lack discipline and organisation, but it is, at the same time, felt they are unbeatable because they are all hoods or cowboys, who will knuckle down and show their tough pedigree when the crunch comes. This is, I suggest, how European popular consciousness responds to the gum-chewing GI's. On this basis the GI's are also identified by Europe's females as being very sexy (i.e. unstiff, liberated). Within the coloured jazz world there is a general resentment that this movement (i.e. the Swing Era), so obviously dependent upon attitudes and techniques evolved by coloured players, passes them by without much recognition or remuneration. The style of the new music derives from the fragmentation of not meaning what one says (i.e. particularly the jam session). For the coloured jazzman the idea of having a private black world in which to negate the demands of white society is assailed by the commercial use of the style of this privacy. Moreover, in a musical context which is becoming increasingly conscious of its identity and history (because of the growth of critical activity), there is the possible recognition, for the black performer, that the musical experience he and his forebears have created is constantly being stolen from him. The growth in critical activity, also, makes it possible for the black performer to view himself as an artist; a perception which, for all the cultural reasons I have been explaining, would have been totally alien to most black

musicians. What European connections there are help to underline these possibilities. For instance, Billie Holiday meets this attitude in Europe and accordingly has her consciousness of herself, and the music she is associated with, transformed by it.

> They've got respect for music over there (Europe). It's culture to them and art, and it doesn't matter whether its Beethoven or Charlie Parker, they got respect. If a kid of theirs comes into the world and says he wants to play they don't act like he was a freak because he wants to be a jazz musician. They stick a horn in his mouth and they see that he gets some lessons. (Billie Holiday *Lady Sings the Blues*)

This she contrasts with the state of play in the States:

> We're supposed to have made so much progress, but most of the people who have any respect for jazz in this country are those who can make a buck out of it. (*ibid.*)

For the black musician the life dedicated to ambiguity cannot be lived simply. This is to say it cannot be lived without cost. What is lost in the two-faced life is a sense of approvable identity. Therefore, social experiences which provide a perspective towards an identity are seductive. The European-style consciousness of jazz introduces coloured jazz musicians to the idea of themselves as artists. The art classification is in a sense Europe's revenge on jazz as the debasement of European culture. Here, then, is a very acceptable identity to assume. In white consciousness there is the recognition of the artist as its highest expression, yet art sets up the artist as badly integrated into the society. This is a totally acceptable image for the segregated black musician seeking a relevant identity. It is, moreover, an identity which allows the player to continue the attack on white society. However, it is an identity which breeds a new confidence and straightforwardness, even if it is expressed in a style which has grown out of a more shifty, two-faced existence. The artist image, and the audience's conferment of this image upon the musician allows him to go on stage, turn his back on the devotees, and blow 'shit'.

Anyone who thinks that an Archie ('America's done me a lot of wrong') Shepp record is anything but two fingers extended from a bunched fist at him personally cannot have much appreciation of what he is hearing (P. Larkin *All What Jazz*).

This straightforward aggressiveness in the jazz setting is symptomatic of more general change in black consciousness in American society. Developments in the jazz world are of the same type as negroes seeking identity through Africa and the Black Muslims, and going on from a base of identity-security to launch black protest. The art status of jazz is, from the beginning of Bop and on through the developments in modern jazz, assured. The perception of jazz as art also builds itself into Revivalism, which is a belated attempt to honour the early jazz as art. Only the old-time musicians and the non-intellectual members of Revivalism's short-lived, mass audience fail to grasp the significance of the perception. Even the American establishment takes jazz up, supporting it as America's unique contribution to the arts. However, this capture of jazz by the art tradition brought about the decline in jazz as popular experience, for jazz was changed by the new outlook of its players. In other words, the supposedly detached perception of what had been going on as a yet unrecognised artistic activity did not leave its object simply uncovered, like the results of an archeological dig. The critical perspective became an active practice, whereby the jazzmen, convinced by themselves as artists, sought to integrate their music into the tradition of art. This is to say that, although there was the blowing of 'shit' (a bourgeois, anti-bourgeois feature of 'high-art' itself), there was also an experimentation with the full-range of techniques offered by modern art music (which jazz now was). As the music began to take on these forms so it lost its popular base. However, there were other aspects to black music in the States (aspects existing privately to blacks) which the critical concentration on jazz overlooked, and it was these that were to go on feeding the repetitious, controlled rebelliousness of capitalist

society, just as the many sides of jazz had done. The jazz
tradition, however, as something to be integrated with a
bourgeois, art-tradition, was, as can be seen from the
account that has been given, a nonsensical project. The style
of the art tradition, even at its most modern and revolution-
ary, reflected a moral concern, an attitude of caring, a desire
to organise the world better, but the style of the jazz tradition
was 'I don't give a fuck' and 'I ain't for real' and ultimately
'I'm an artist man, so pay for my dinner'. The jazzman has
experienced this merger as a great difficulty. In *Beneath the
Underdog* Mingus laments the fact that he cannot be like a
member of the Juilliard String Quartet (i.e. nameless and
simply concerned with music), that he cannot in jazz fulfil
himself as a composer ('artist'). Jazz has, he says, too many
strangling qualities, it 'leaves room for too much fooling'.
(Charles Mingus, *Beneath the Underdog*, p.340). In fact,
since being absorbed into the fringes of the art life in society,
jazz has not developed. There is the 'shit', there are the
attempts to preserve revered sectors of the past, there is the
playing of modern, serious, art music under the label of jazz,
and, in a few cases, there are jazzmen functioning in the rock
world whilst preserving a jazz feel.

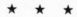

The aim in writing this chapter has been to cut through the
abstract question 'Is jazz art?' and to suggest that the base
which allows the question to be asked is what gives the
question significance, rather than the question as contempla-
ted literally. The social perceptions of jazz as art have been
various both in location and motive. In trying to bestow
honours on jazz they have failed, as far as previous forms of
jazz music are concerned, to understand its intentional
practice and thus its significance in its own social context. Of
course, as I have tried to suggest, the application of art
ideology to jazz has often taken place on the basis of
self-deception. The description 'art' has often been the cloak

under which jazz has been contemplated for its actual significances. However, again for various reasons, these actual significances have undergone large transformations through contact with the theoretical practices of bourgeois society. The net effect has been the absorption of jazz and its history into the fringes of the art process in society. Perhaps the fact that the history of jazz has been anti-European, anti-white, anti-bourgeois, anti-art accounts for its peripheral rather than central position (i.e. as something difficult to integrate into the art tradition). With the absorption of jazz into the art process has come the decreasing significance of jazz as a catalyst for popular, mass experience. Moreover, through the identification the jazz process has run itself into a cul-de-sac. The art interpretation has not sprung from the clear perceptions of unprejudiced, morally sympathetic minds, but has grown out of the social needs of specific social groups and from the way these needs have meshed together. It has proffered misunderstandings and misinterpretations of jazz, and has led to the death of jazz as popular experience and to its decline as any kind of developing social process. In other words there were other possibilities for the jazz process. Its route has been a chosen route, it has been nothing other than the practice of persons. The choices made are explicable and intelligible, but, I venture, it would have been better for the life of jazz if the jazzman's 'piss off' response to the 'cultural' interest in what he was doing had been meant rather than assumed as a theatrical pose within the 'cultural context'. Art is a value the masses should resist, not just ignore.